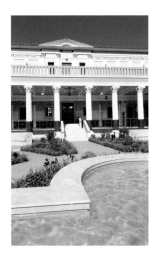

Guide to the Getty Villa

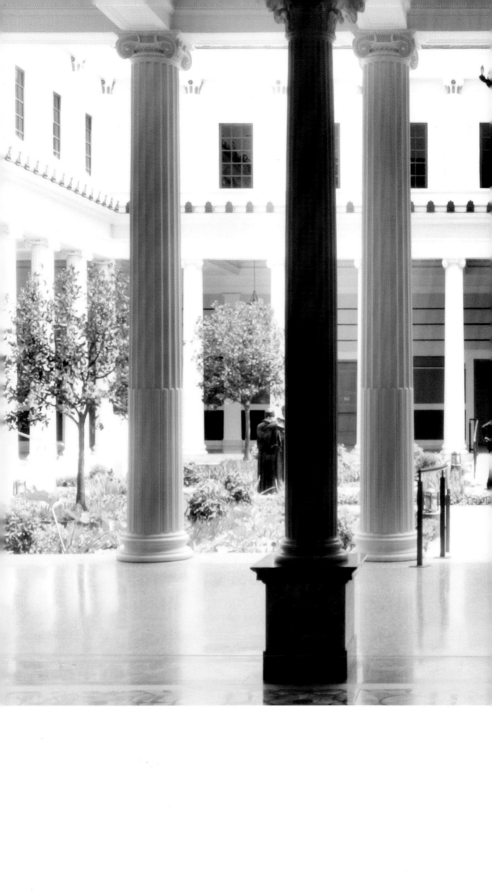

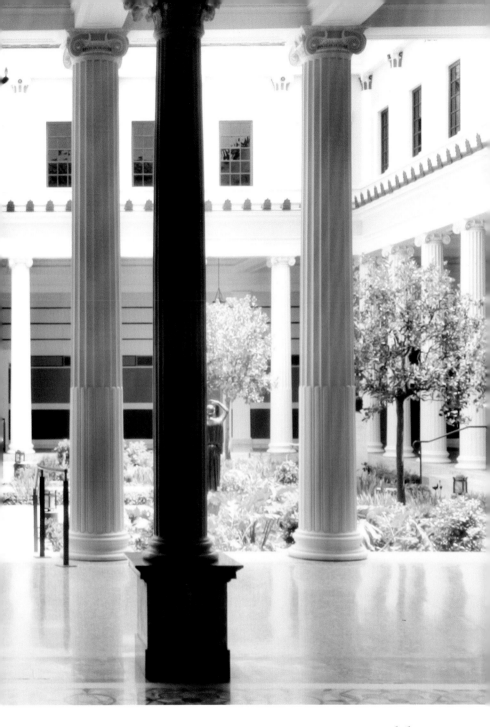

Guide to the Getty Villa

The J. Paul Getty Trust
Los Angeles

© 2005 J. Paul Getty Trust

Getty Publications
1200 Getty Center Drive, Suite 500
Los Angeles, California 90049-1682
www.getty.edu

Christopher Hudson, *Publisher*
Mark Greenberg, *Editor in Chief*

Abby Sider, *Copy Editor*
Benedicte Gilman, *Editorial Coordinator*
Jim Drobka, *Designer*
Elizabeth Chapin Kahn, *Photo Researcher and
 Production Coordinator*
Printed in Singapore by CS Graphics
Separations by Professional Graphics,
 Rockford, Illinois

On the front cover: View from the portico of
the Getty Villa down the length of the Outer
Peristyle garden.

On the back cover: Aerial view of the Getty
Villa from the southwest.

Half-title page: The South Portico and
Balcony of the Museum building.

Title page: The Inner Peristyle of the Museum
has an Ionic colonnade on all four sides. The
two Corinthian columns in the foreground
mark the transition from the peristyle to the
space that was the *tablinum* (dining room) in
the ancient Villa dei Papiri, and which now as
then opens on the opposite side to the large
Outer Peristyle.

Page 6: In this charming detail from the wall
paintings in the Getty Museum's Outer
Peristyle, a bird seemingly perched on a ledge
curiously eyes a grasshopper.

Page 126: The Inner Peristyle lit up at night.

Editor's note: Drawing upon the work of
numerous individuals, Kenneth Lapatin pro-
duced the text for this Guide. Chapter 1 is
adapted from an essay, "The Museum in
Context," written in 1987 by then Museum
Director John Walsh and published in a pre-
vious edition of this Guide. Other contribu-
tors to earlier Museum publications on
whose work this Guide draws freely are
Andrea P. A. Belloli, Jeanne D'Andrea,
Stephen Garrett, Benedicte Gilman, Deborah
Gribbon, Elizabeth Kahn, Anne Kresl, Sandra
Knudsen, Norman Neuerburg, Marion True,
Barbara Whitney, and other staff members,
scholars, and friends of the Museum too
numerous to acknowledge individually. The
assistance, enthusiasm, and knowledge of all
are greatly appreciated.

*Library of Congress
Cataloging-in-Publication Data*

J. Paul Getty Museum.
 Guide to the Getty Villa.
 p. cm.
 Includes bibliographical references.
 ISBN-13: 978-0-89236-828-0 (pbk.)
 ISBN-10: 0-89236-828-4 (pbk.)
 1. Getty Villa (Malibu, Calif.) 2. J. Paul
Getty Museum. 3. Architecture, Roman—
Influence. 4. Art—California—Malibu.
5. Malibu (Calif.)—Buildings, structures, etc.
I. Title.

N582.M25A87 2005
727'.7'0979494—dc22

 2005049290

Contents

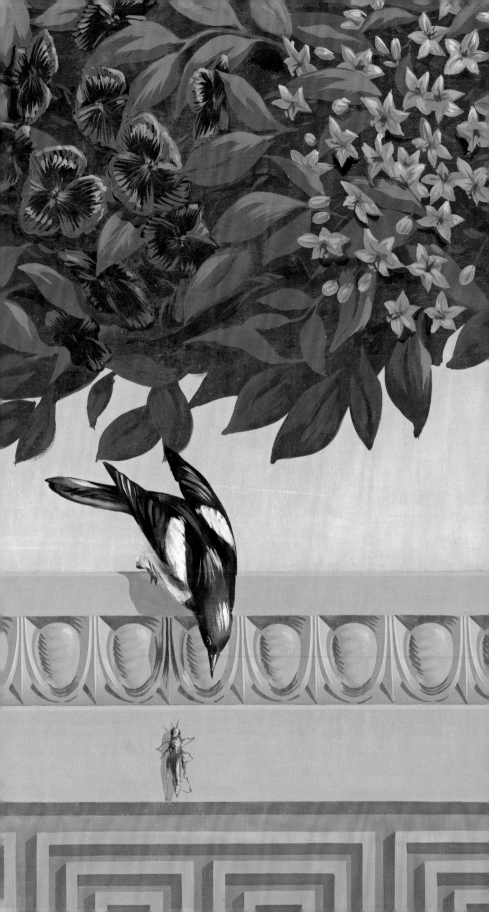

Foreword

When J. Paul Getty decided to build a replica of the ancient Villa dei Papiri at Herculaneum on his Malibu estate, he hoped it would allow visitors to experience the kind of opulent setting that would originally have housed many of the objects in his collection of Greek, Etruscan, and Roman artifacts. From the time the Getty Villa was completed, in 1974, public interest in and affection for it have grown, and, following its closure for renovation in 1997, its reopening has been eagerly anticipated. Those who knew the old Villa will find it familiar, yet transformed, for the Getty Museum's nonclassical collections have all been moved to the Getty Center in Brentwood, and the Villa is now dedicated entirely to the art and culture of classical antiquity. Dramatic new features include not only expanded and light-filled galleries for the permanent collection and dedicated spaces for special exhibitions but also a new Entry Pavilion, Museum Path, an outdoor classical theater, an expanded Cafe, Museum Store, and Auditorium, as well as much-needed additional parking. Offices, a library, and conservation laboratories for staff, visiting scholars, and students in the UCLA/Getty Masters Program on the Conservation of Ethnographic and Archaeological Materials are additional enhancements to the site, the transformation of which was overseen by the architectural firm of Machado and Silvetti.

This *Guide*, an update and expansion of earlier editions, is based on the work of many individuals. Kenneth Lapatin revised and added to the text in light of changes at the Malibu Villa and new discoveries at Herculaneum. Guy Wheatley in Malibu and Valerio Papaccio in Herculaneum kindly answered detailed queries; Benedicte Gilman's editorial skills and knowledge of both sites improved the text; Elizabeth Kahn searched the archives for new documentation; Richard Ross supplied beautiful new photographs; and Jim Drobka assembled these raw materials into a pleasing design. Numerous other members of the Getty staff, friends, and supporters have contributed to making the Villa what it is today. We all hope that visitors will enjoy its latest incarnation as much as they did its earlier form.

Marion True
Curator of Antiquities and
Trust Coordinator for Villa Programs

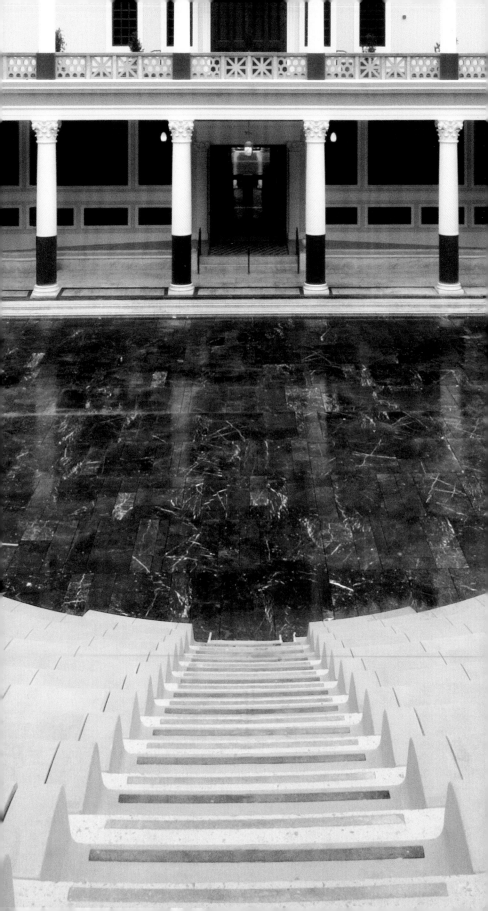

The Museum in Context

INCE IT OPENED in 1974, the Getty Museum has been a popular destination for visitors wishing to experience its architecture and setting and to view the works of art it houses. The Malibu Villa (which is actually located in Pacific Palisades, in the City of Los Angeles) is a reconstruction and adaptation of a Roman villa at Herculaneum, one of many ancient towns on the Bay of Naples that was buried by the eruption of Mt. Vesuvius in A.D. 79. Partially excavated in the eighteenth century and named after the hundreds of carbonized papyrus book rolls found there, the Villa dei Papiri was one of the most luxurious private residences of the ancient world. Evidence suggests that it belonged to Lucius Calpurnius Piso Caesonius, the father-in-law of Julius Caesar. (Thus it is also occasionally called the Villa dei Pisoni.)

■ The young
J. Paul Getty.

J. Paul Getty (1892–1976) was one of the richest men of the twentieth century. A phenomenally successful oilman, he made his first million dollars at age twenty-three but did not begin collecting art seriously until the 1930s. His collections were initially housed in his various residences, including the Spanish-style "Ranch House," located north of the Villa, on

■ The main entrance to the Museum is through the portico behind the Barbara and Lawrence Fleischman Theater. The semicircular stone seats of this theater are modeled on outdoor theaters in ancient Greece and Rome.

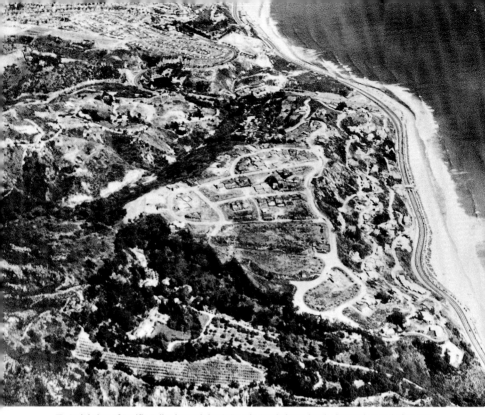

■ Aerial view of Pacific Palisades and the Cañon de Sentimiento (at the bottom) years before construction of the Villa. Mr. Getty's Ranch House is visible at the lower left, surrounded by lemon groves.

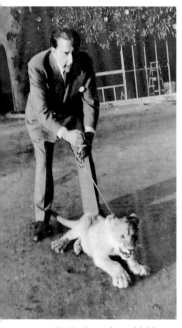

■ Mr. Getty plays with his favorite pet lion cub on the grounds of his Malibu property.

■ The antiquities gallery of the Getty Ranch House shortly after its opening in 1957. The Lansdowne Herakles occupied a prime location in front of the window at the far end.

■ The Ranch House in the late 1950s. This building has gone through several renovations. Today it houses offices for curators and scholars, conservation labs, classrooms, and a research library.

the 64-acre Malibu site in the Cañon de Sentimiento, which he purchased from Los Angeles attorney Claude Parker in 1945 for $250,000. Parker had bought the land in the 1920s from Perfecto Márquez, a descendant of the original Spanish land-grant holder for the Rancho Boca de Santa Monica. Mr. Getty was an admirer and emulator of William Randolph Hearst and his compound at San Simeon. Thus he not only installed his growing art collection in the house, but he also created a small zoo on the property. It included bears, lions, bison, wolves, gazelles, and sheep. Renovations to the Ranch House, including the addition of a second story, were completed in 1948. In 1953, wishing to make his collection available to the public, he established the J. Paul Getty Museum. It opened within the Ranch House in May 1954. Unable to attend the Museum's opening, Mr. Getty wrote from Kuwait: "I hope this museum, modest and unpretentious as it is, will nevertheless give pleasure to many people around Los Angeles who are interested in the periods of art represented here."

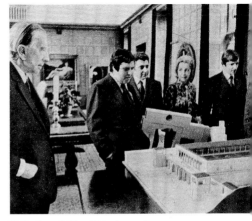

■ Mr. Getty (left) and friends examine a model of the Villa displayed in his home in England in 1974.

EARLY PLANS FOR EXPANSION Although the Museum was initially open just two afternoons a week and saw barely a thousand visitors a year, Mr. Getty added a specially built gallery to the Ranch House in 1957 to accommodate the growing collections, and by 1968 he decided to construct an entirely new building, one that—ironically for the late 1960s, the height

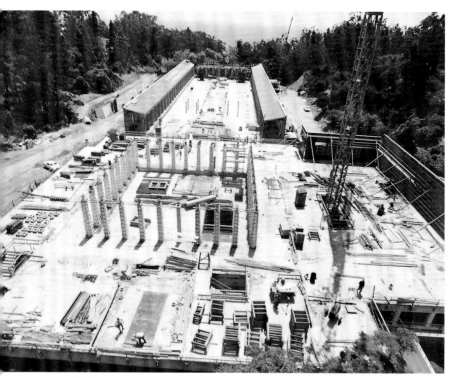

■ The Villa under construction in the early 1970s, viewed toward the sea. The columns of the Inner Peristyle are in the middle ground and the roofed colonnades of the Outer Peristyle are near the top.

of modernism in architecture—was to be modeled on the distant past. Having rejected other proposals, Mr. Getty explained his choice: "The principal reason concerns the collection of Greek and Roman art which the museum has managed to acquire . . . and what could be more logical than to display it in a classical building where it might originally have been seen."

Logic, of course, was not the only motivation. Mr. Getty was not fond of modern architecture and preferred to build in a style that he personally found appealing: "It will simply be what I felt a good museum should be, and it will have the character of a building I would like to visit myself. . . . Why not show Californians what an especially attractive Roman building would have looked like, with its gardens, fountains—even details such as the lamps and appropriate flowers? Many contemporary museum buildings have failed while attempting less than that."

CONSTRUCTION BEGINS Ground was broken in December 1970, and construction proceeded rapidly, with Mr. Getty making both major and minor decisions long-distance from his home in England. He monitored the process by means of constant reports, large-scale photoboards, and even films, while work on-site was overseen by the Los Angeles architectural firm

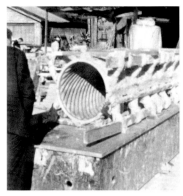

Modern techniques were used to fashion the "ancient" building. The spiral columns of the west Entrance Porch were cast in molds like this one.

Workmen carefully lay the mosaic pavement of the former Roman gallery.

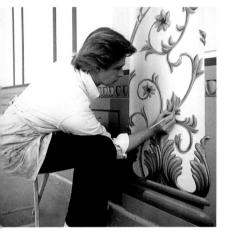

Artist Garth Benton puts the finishing touches on one of the murals painted on the walls of the Outer Peristyle.

Langdon Wilson. Craftsmen came to the job from all over America and Europe. Crews were even recruited from Hollywood studios. The new J. Paul Getty Museum opened its doors to the public on January 16, 1974.

To many at the time the Museum was planned and built, the idea of re-creating an ancient Roman villa seemed to be whimsy at best, and folly at worst. Critics condemned the Villa by adding it to the list of local insults to cultivated taste: the genial fantasy of Disneyland, the flimsy historicism of Hollywood sets, and the eclectic ersatz of the mansions and restaurants of Beverly Hills. It was repeatedly said that seventeen million dollars should have bought a more distinguished modern building, one that would have advanced the art of architecture, not set it back. Besides, a few writers claimed, the Villa wasn't a correct reconstruction, but a faulty pastiche, combining in its modern fabric elements of various ancient buildings not present in the ancient Villa dei Papiri at Herculaneum. Yet others complained that it was too correct. What some saw as gaudy vulgarity, others took to be bloodless fussiness.

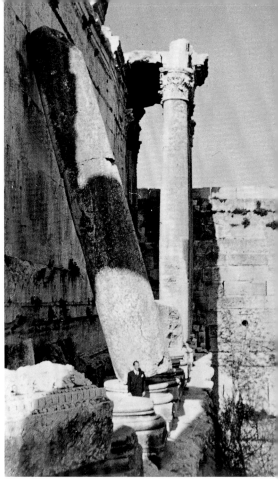

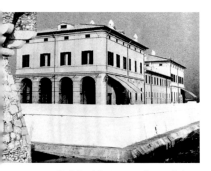

J. Paul Getty not only traveled widely but also owned several homes abroad, including this villa at Palo, on the coast 30 miles northwest of Rome.

The columns of the Temple of Bacchus at the impressive Roman site of Heliopolis (Baalbek) in Lebanon dwarf Mr. Getty.

But everybody, including Mr. Getty, who was eighty-one years old when the Villa opened and never managed to visit the completed Museum in person, agreed that it pleased the public. A few subtle minds drew interesting conclusions from this situation. Joan Didion thought the building affronted the critic and pleased the layman because it reminded them both that rich Romans did not live in the mellow austerity of our dreams of antiquity (and their own professed ideals) but in colorful ostentation. Thus for her the Museum was "one of those odd monuments, a palpable contract between the very rich and the people who distrust them least." Earlier, the architectural historian David Gebhard had seen the Museum as successful populist architecture. All designers have models, he wrote, whether they know them or not. "Even if a case could be made that ethics and design are somehow related," he asked, "why is it reprehensible to employ forms of the distant past, rather than borrowed forms of the near past?" This question, provocative in 1974, is hardly raised in our postmodern age. The debate has now

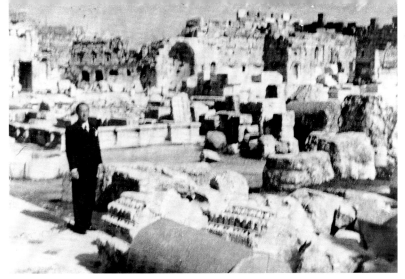

■ Mr. Getty amid the ruins of a large courtyard near the Temple of Jupiter at Heliopolis (Baalbek) in Lebanon.

shifted from whether such borrowings are legitimate to what forms should be borrowed, and how, and on what basis. These are the challenges that were faced by the Boston architects Rodolfo Machado and Jorge Silvetti, when they came to remodel the Museum building and design new amenities for both staff and public between 1997 and 2005.

GETTY'S INTEREST IN HISTORY Mr. Getty's original decision to re-create the Villa dei Papiri may be easier to understand if we consider that it was no sudden whim of the late 1960s, but the realization of a fantasy that had been in his mind for many years. A surprising side to this unfathomable man, so stolid and practical to all appearances, was his lively interest in history. He first visited Herculaneum in 1912, at age nineteen, and later he mused upon the distinguished former owners of his works of art (including the Roman emperor Hadrian; Kings Louis xiv, xv, and xvi of France; Lord Elgin; the Duke of Argyle; the Marquess of Lansdowne; and William Randolph Hearst). He also pondered his own place in chronicles yet to be written. Other American businessman-collectors had a similar bent—about J. P. Morgan an embittered Roger Fry (a painter and critic) wrote, "A crude historical imagination was the only flaw in his otherwise perfect insensitivity"—but unlike them, Mr. Getty was attuned to works of art and prone to writing down his flights of historical fantasy.

In 1955, the year after the original Getty Museum opened in the Ranch House, he published a novella called *A Journey from Corinth* in which the actual Villa dei Papiri figures prominently. In this anachronistic story a young couple emigrates from Corinth to Neapolis (ancient Naples) in the second century B.C. The husband, Glaucus, a landscape architect, enters the employ of Lucius Calpurnius Piso at his great villa at Herculaneum.

Mr. Getty's sketch of Piso has more than a little of the self-portrait about it: "one of the richest men in Italy… a pleasant looking Roman in his mid-thirties although a trifle pompous in manner." The Roman orator Cicero presents a rather less flattering picture of Piso, who as proconsul of Macedonia ruled over all of Greece from 57 to 55 B.C. Cicero was connected to Piso by marriage, but loathed him for having connived at Cicero's exile:

> He has nothing to recommend him save an hypocritical assumption of austerity, neither mental vigor, nor eloquence, nor military skill, nor an interest in the study of mankind, nor liberal culture. If you happened to see that unkempt, boorish, sullen figure in passing, you might have judged him to be uncouth and churlish.…Talking with him is much the same as holding a discussion with a wooden post in the Forum. You would call him stockish, insipid, tongue-tied, a dull and brutish clod … plucked from some slave dealer's stock-in-trade … profligate, filthy, and intemperate. (*Post Reditum in Senatu* 6.13−14)

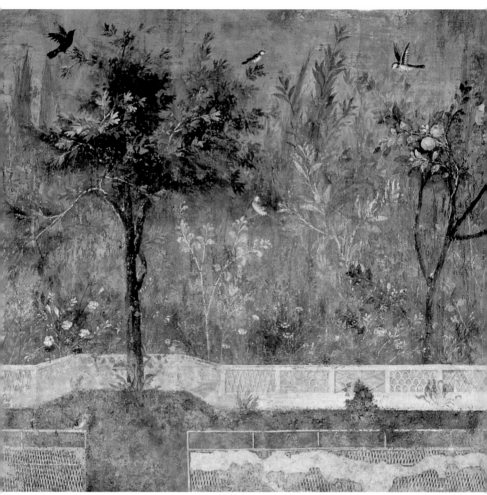

The Romans often painted the walls of small or enclosed rooms with expansive landscapes and architectural views. This fresco from the villa of the empress Livia at Prima Porta outside Rome shows a variety of plants and animals in a delightful garden scene.

Meanwhile, in Mr. Getty's more sympathetic fantasy:

> Calpurnius Piso owned one of the largest villas in that part of Italy. Its buildings covered some ten acres, and its gardens extended along the sea-coast for over half a mile. Piso was born in Rome, the only child of a very rich father who was now Consul. He had hoped to make a career for himself in politics, but after a brief experience decided that he possessed little political ability; and since he was a man of great wealth, would be better out of political life than in it. Subsequently he left Rome, bought some two hundred acres of land on the Bay of Naples — adjoining the little village of Herculaneum — and in recent years occupied his time building this great villa. The work had progressed well. Only some of the gardens remained to be completed.

Glaucus is hired and does great work for Piso. Later in the story, his hometown of Corinth is captured by the Romans and sacked. A vast trove of works of art is removed to Italy, and an auction is arranged in Neapolis (a parallel with Mr. Getty's own first purchases at auction for bargain prices in Europe during the Great Depression). At the sale Piso forms the beginning of an important collection with the advice of Glaucus. Among the things he buys is a statue of Herakles (the Lansdowne Herakles, one of Mr. Getty's prized possessions and one of the highlights of the Museum's collections, but certainly never owned by Piso), which, in Mr. Getty's fable had stood earlier in the marketplace of Corinth, where it had long been a favorite of Glaucus and his bride. The statue is then proudly installed by Piso in the Villa dei Papiri, is later given to Nero, and then passes to Hadrian—another notable villa builder whom Mr. Getty admired and with whom he identified. In a kind of afterword to this romance, Mr. Getty records that the statue finally made its way to England and then "followed the sun westward to the New World."

It is worth noting that Glaucus got the job at the Villa dei Papiri only after Piso asked him many questions and finally said, "[Y]ou seem to have a flexible mind. If you understand that I mean to have my own way in landscaping, and you wish to act as my assistant and further my efforts, instead of trying to

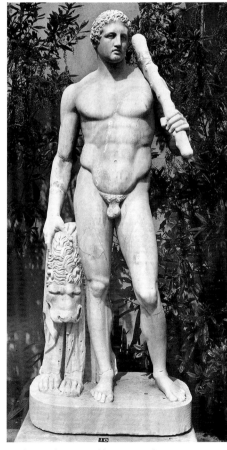

■ The Lansdowne Herakles, Mr. Getty's favorite work of art, was first displayed outdoors in a courtyard of the Ranch House.

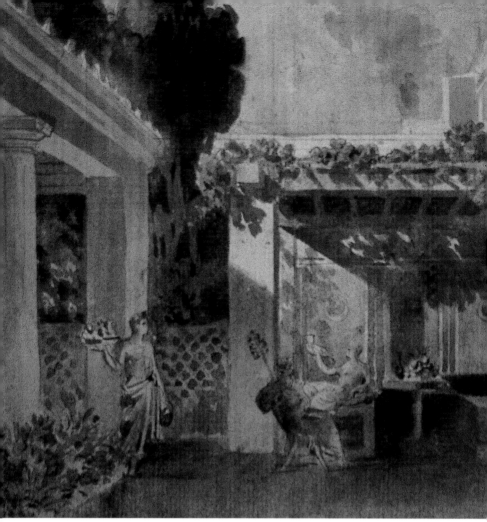

■ Imaginary scene of a Roman garden showing a couple relaxing in the shade of an arbor next to the peristyle of a restful and shady garden of a large and elegant house. Jules Frédéric Bouchet (French, 1799–1860), Graeco-Roman patio scene. Watercolor and pencil on paper, 16.3 x 21.2 cm. GRI no. 2003.M.6*.

thwart them, you and I should get along very well." It is as though Mr. Getty were warning his future architects. Had they read his book, his advisers might have been less astonished some dozen years later by his command to reconstruct the Villa dei Papiri.

INFLUENCE OF ANCIENT ROMAN VILLAS If the reborn villa embodies Mr. Getty's fantasies about the men he thought of as his antecedents in ancient Rome, it also continues several important architectural traditions. These have little to do with Los Angeles, let alone Disneyland, but a good deal to do with American and European practice of the nineteenth and twentieth centuries. The notion of putting an art collection into an elaborate house designed partly for that purpose seems to have been a Roman

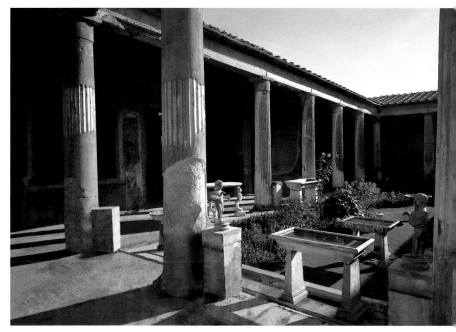

■ The peristyle garden of the House of the Vettii at Pompeii illustrates the combination of plants, fountains, and sculptures that typically decorated the gardens of wealthy Romans.

invention, and indeed the original Villa dei Papiri, like many other country houses, was a kind of private museum. The owner of the villa and his guests, having escaped the crowded city, could refresh their senses and their intellects. The Romans called this type of leisure *otium.* Its opposite was *negotium:* business. Owners of luxury villas placed wall murals, panel paintings, statues, and various portable treasures where they could give delight in concert with the peristyles, gardens, fountains, and other architectural contrivances including vistas through rooms and, for the extremely wealthy, views out to the sea. The poet Statius, for example, describes the villa of Pollius Felix at Sorrentum (modern Sorrento) on the Bay of Naples, whose "colonnade climbs up the cliff, vast as a city, and its long line of roof gains mastery over the rugged rocks." One part of the house faces east, taking in the morning sun, the other west, catching the last rays of the afternoon. "Here the sound of the sea is heard in the rooms; there, no sound of the roaring waves, but rather the silence of the land." The poet not only praises the building and its setting but also inventories its contents: colored marbles imported from the Aegean islands and the shores of the Mediterranean; the works of ancient Greek masters in sculpture and painting; portraits of political leaders, prophets, and wise men. All this, perhaps, is hyperbole, but Cicero, in his rather more sober letters to his friend Atticus, writes of the "Academy" and gymnasium he built in his villa in Tusculum and decorated

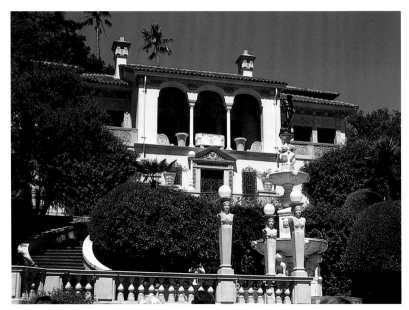

William Randolph Hearst's estate at San Simeon on California's Central Coast is a Spanish-style fantasy filled with original architectural elements and works of art.

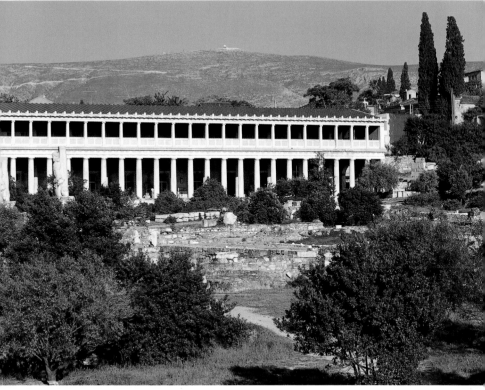

The two-story Stoa of Attalos in the ancient *agora* (marketplace) of Athens was rebuilt on its ancient foundations in the 1950s to house the Agora Museum. Like peristyles in private houses, the porticoes of the Stoa offered protection from sun and rain.

with statues as suitable places for thought and inspiration. Excavation of the Villa dei Papiri has revealed similar desires on the part of its owner, and copies of some of the many works of art found there have been installed in the gardens of the Getty Villa.

PREVIOUS HISTORICAL RECONSTRUCTIONS By adapting an ancient villa to house his collections, Mr. Getty was reviving an older and purer form of the house-as-museum, a type he knew especially well in his adopted home of England, which abounds in houses-become-museums, both in the city (the Wallace Collection in Hertford House, the Wellington Museum in Apsley House) and outside it (the Iveagh Bequest at Kenwood, and innumerable others). As Mr. Getty clearly realized, several generations of well-to-do Americans had installed their art collections in newly built palazzi and great houses, whether Venetian (Isabella Stewart Gardner in Boston), French (Henry Clay Frick in New York), English (Henry E. Huntington in San Marino), or Spanish (William Randolph Hearst at San Simeon). One such millionaire, John D. Rockefeller, had made a specialty of sponsoring historical reconstructions for museum buildings. Rockefeller did this on a grand scale, putting a sizable part of his oil fortune into a series of projects that cannot have failed to impress Mr. Getty and feed his ruminations on what he himself might build one day. One of the most successful of Rockefeller's projects, The Cloisters in New York City, is a group of buildings and courtyards in medieval style overlooking the Hudson River, a *musée d'ambiance* that evokes strong associations with the remote European past while providing all the modern conveniences. Just as suggestive for Mr. Getty the amateur archaeologist would have been the Stoa of Attalos, an imposing two-story Hellenistic commercial building reconstructed from its foundations in the Agora of Athens with Rockefeller support between 1953 and 1956. The stoa now houses the American School of Classical Studies at Athens and serves as a museum containing works excavated in the Agora.

IMAGINING THE PAST Roman villas, as described by ancient poets such as Statius and the prose authors Vitruvius and Pliny the Younger, have occupied the imaginations of architects since the Renaissance. And ever since the rediscovery of Pompeii and Herculaneum in the eighteenth century, there have been countless attempts to reconstruct the ancient houses there on paper. King Ludwig I of Bavaria even had a Pompeian house built for himself at Aschaffenburg, and Prince Albert built another for Queen Victoria on the grounds of Buckingham Palace. Mr. Getty's interest in the subject was therefore nothing new. When he engaged the architectural historian Norman Neuerburg as consultant to re-create the Villa dei Papiri on the basis of archaeological evidence, Mr. Getty was reviving a tradition that only recently had lapsed after several centuries of vigorous continuity.

■ The Pompeian Room in the Garden Pavilion at Buckingham Palace in London, designed by Agostino Aglio and built at the instigation of the Prince Consort by L. Grüner in 1844. Demolished in 1928.

Nineteenth-century architectural students at the French Academy in Rome were frequently required to submit drawings of buildings at Pompeii. These measured studies of the ruins and renderings of the buildings as "restored" in the imagination of the architects are the direct antecedents of the Getty project. The large, vividly colored drawings not only depict plans and elevations of entire reinvented building complexes but also provide a vivacious account of the bright murals and lavish decor. To succeed at the academy, students not only had to know the hard evidence of the remains, they also had to try to think like a Roman architect. They had to know all the comparable ancient buildings so as to invent more confidently.

■ Matthieu-Prosper Morey (French, 1805–1886), Architectural record drawing of a wall painting from Pompeii. Pencil, pen and ink, watercolor.

The aim of these exercises was not so much an accurate restoration as a plausible, harmonious pastiche. This was also the task of Dr. Neuerburg as he set about designing an adaptation of the Villa dei Papiri, a building known from an incomplete ground plan of tunnels dug in 1754, and whose elevations are, for the most part, a mystery (although new excavations in the 1990s have revealed more information). Naturally the construction of the Getty Villa was infinitely complicated by the purpose of the building: not to house a family and its possessions, but to be an up-to-date public museum.

MR. GETTY'S LEGACY Had the circumstances of the J. Paul Getty Museum remained the same after it opened, little might be different at the Villa today. But on June 6, 1976, when Mr. Getty died at the age of eighty-three, he left the Museum an extraordinary bequest of four million shares of Getty Oil stock worth about $700 million. This opened up new possibilities. Whereas the collections had been limited in his time to Greek and Roman antiquities, French furniture and decorative arts, and European paintings, they could now be broadened to include sculpture and other European works of art, drawings, illuminated manuscripts, and photographs. To show all this without adding to the Villa made it necessary to rearrange the galleries extensively. Just as the original Villa dei Papiri was altered by its successive owners over the years, so the interiors of the original Ranch House and the Malibu Villa have changed and changed again to accommodate the growing collections, staff, conservation facilities, and public services.

It soon became plain, however, that only another, yet larger Getty Museum could hope to do justice to the collections. Mr. Getty's legacy gave his Trustees a chance to create a group of organizations to benefit the fields of scholarship and conservation in the visual arts and also allowed them to embark upon the construction of the Getty Center, a complex of buildings designed by the architect Richard Meier on a 24-acre building site that is part of a dramatic 750-acre tract on a spur of the Santa Monica Mountains in Brentwood. Alongside the headquarters of the Getty Trust and its various programs, the new Getty Museum houses all of the collections except antiquities, although a small selection remains on display at the Getty Center.

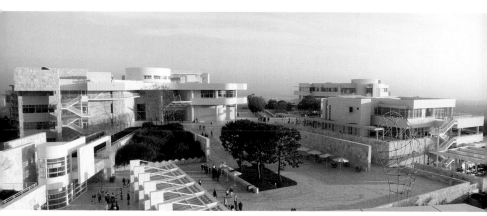

■ The Getty Center in Brentwood opened in 1997. The Museum (left) houses the nonancient collections of the J. Paul Getty Museum. Separate buildings accommodate the other programs of the Getty Trust: Research Institute, Conservation Institute, and Foundation (formerly the Grant Program).

A FOCUS ON ANCIENT ART A few months before the Getty Center opened in December 1997, the Villa closed so that the collections could be moved from Malibu to Brentwood. A short time later, work on the Villa began in order to bring the building up to code and up to date, so that it could serve as America's only museum devoted entirely to Greek, Etruscan, and Roman art. The new master site plan included not only refurbishment of the Villa itself, with built-in state-of-the-art technology for the installation and display of ancient works of art, but also new amenities for visitors, staff, scholars, and students.

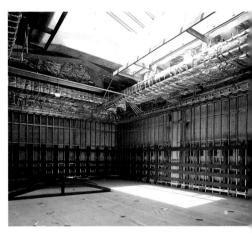

From expanded parking facilities, a new Entry Pavilion opens onto a Museum Path that leads visitors alongside the Villa, where they can look down onto the site, rather like those who journey to the Herculaneum excavations. Descending into an open-air, Greek-style theater, where concerts and ancient dramas are staged periodically, visitors can enter the Museum through the Villa's Atrium, or proceed to the

▨ A specially devised art-support system hidden in the walls and floors of the galleries in the Getty Museum provides flexibility for changing displays without sacrificing stability.

new Museum Store, Cafe, or 250-seat Auditorium. Beyond these public spaces is the remodeled Ranch House, which now houses curatorial offices, conservation laboratories, a research library, seminar rooms, and facilities for visiting scholars and students in the joint UCLA/Getty Masters Program on the Conservation of Ethnographic and Archaeological Materials.

J. Paul Getty thought collecting art was "one of the most exhilarating and satisfying of all human endeavors." Yet he was convinced that "the true collector does not acquire objects of art for himself alone. His is no selfish drive or desire to have and hold a painting, a sculpture, or a fine example of antique furniture so that only he may see and enjoy. Appreciating the beauty of the object, he is willing and even eager to have others share his pleasure." In fact, in 1939, the same year that J. Paul Getty purchased his first piece of ancient art, he anonymously lent his *Portrait of Marten Looten* by Rembrandt to be exhibited in the Fine Arts Pavilion of the New York World's Fair. This enabled him "to share [his] joy in owning the masterpiece with millions of people." He donated that painting along with other works of art to the Los Angeles County Museum of Art before founding his own museum. Later, he conceived of the Villa as a major art museum that he

■ The old paintings gallery on the second floor of the Villa (top) was an interior space with no natural light. In the remodeled Villa, this room (Gallery 207) has been transformed into an entirely new space by the installation of a large skylight, windows, and a terrazzo floor. A grid of steel beams hidden in the walls of the galleries can support heavy sculpture and mosaics, while regularly spaced jacks incorporated into the terrazzo floors provide anchors for pedestals and cases as well as electrical and data conduits.

could leave as a gift to the people of Los Angeles: "It was my intention that the collections should be completely open to the public," he wrote. And being aware that museums are often imposing and intimidating, he hoped that the human scale of the Villa and its intimate connection with gardens and nature would appeal to visitors: "I would like every visitor at Malibu to feel as if I had invited him to come and look about and feel at home.... I hope that it will prove to be as beautiful as I imagined it and that everyone who wants will have a chance to see it."

Mr. Getty recognized that encounters with ancient art constitute a kind of time travel: "The collector can, at will, transport himself back in time and walk and talk with the great Greek philosophers, the emperors of ancient Rome, the people, great and small, of civilizations

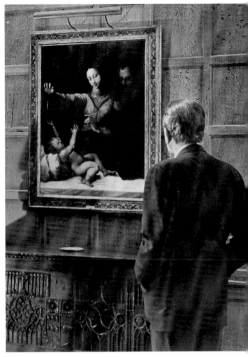

Mr. Getty looks at one of his favorite paintings, bought at auction in 1938. After Raphael (Italian, 1483–1520), *The Holy Family*, mid-sixteenth century. Oil on panel, 120.5 x 90 cm. J. Paul Getty Museum, 71.PB.16.

long dead, but which live again through the objects of his collection." By building the Villa for the public at large, Mr. Getty provided a greatly enhanced opportunity for such an experience. His goals did not end there, however. "In learning about ancient Greek and Roman art," he wrote, "one cannot help but also learn about the civilizations and the people who produced the art. This will unquestionably serve to broaden the individual's intellectual horizons and, by increasing his knowledge and understanding of past civilizations, greatly aid him in knowing and understanding our own." As Mr. Getty's last will and testament made clear, he intended that his legacy be employed to further "the diffusion of artistic and general knowledge." It is our hope that through its collections, research and conservation facilities, and diverse public programs—introductory talks, lectures, seminars, symposia, publications, exhibitions, audio guides, interactive computer programs, family events, concerts, and theatrical productions—the renewed Getty Villa will continue both to delight and to serve the public, just as its founder intended.

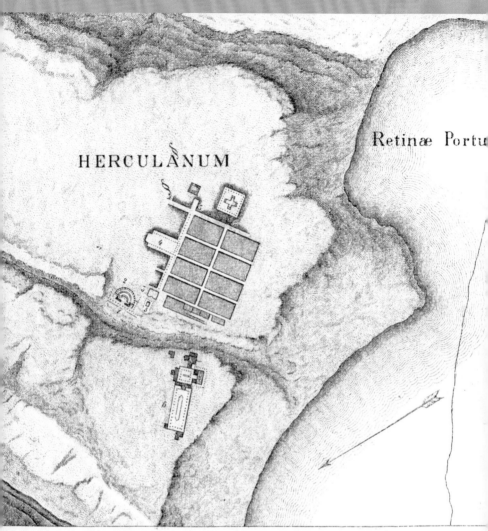

HERCULANUM

Retinæ Portu

1. *Puteus, ex quo prima consepultae urbis rudera et signa emerserunt.* 2. *Theatrum.* 3. *Forum.* 4. *Basilica.* 5. *Templo* 6. *Domus pseudourbana, ubi volumina sunt reperta* ⌐ *Hac linea designatur quousque in praesenti litus procurra* 𝒮 *Sepulcretum*

Metà di un miglio da 60 a grado o metri 925.925.

| | | | | |
|100|200|300|400|500|

Franciscus la Vega investigavit et descripsit

RICHTER & C. NAPOL.

Rediscovering
the Villa dei Papiri

I N ANTIQUITY, the Villa dei Papiri was located on the coast just outside Herculaneum. The city of Herculaneum was dedicated to the hero Hercules (Herakles in Greek). With a population estimated to have been four to five thousand, it was smaller than Pompeii, a bustling commercial center to the southeast.

Campania, the region south of Rome in which these cities were located, was prized for its fertility and mild climate. Although settled by Greeks as early as the eighth century B.C., Campania was, by the first century, a favorite country retreat of the Roman aristocracy. The region owed its fertility to Vesuvius, the volcanic mountain that dominates the landscape to this day. But the ancients seem to have had little idea of the danger the volcano

■ Plan of Herculaneum showing, at the bottom, the location of the Villa dei Papiri just outside the town itself, beyond a gully. The ancient coastline is very close to both the villa and the town, while several eruptions of Mt. Vesuvius have pushed the modern coastline further out. From Michele Ruggiero, *Storia degli scavi di Ercolano* (Naples, 1885), pl. II.

■ This marble relief from the House of Lucius Caecilius Jucundus at Pompeii shows the damage done by the earthquake of A.D. 62.

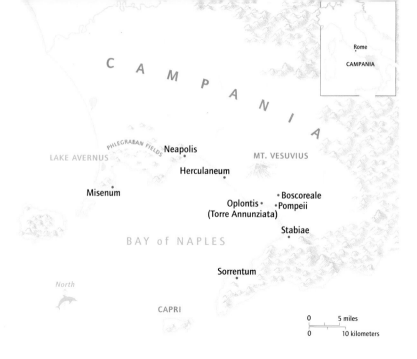

presented. Although they were aware of bubbling earth in the nearby Phlegraean Fields and steaming Lake Avernus, which they considered an entrance to the underworld, they thought the volcano itself extinct and seem not to have associated it with the disastrous earthquake that struck the region in A.D. 62. They set about rebuilding, and the minor earth tremors that preceded the devastating eruption of Vesuvius in A.D. 79 seem to have been so common as to cause little alarm.

VESUVIUS ERUPTS We are fortunate—if that is the right word—to have a firsthand account of the cataclysmic eruption of A.D. 79, which began on August 24. It was a holiday: the official celebration of the birth of the deified emperor Augustus and, ironically, the feast of Vulcan, the Roman god of subterranean fire. According to Pliny the Younger, the mountain exploded shortly after midday. For twelve hours pumice and ash rained down from the sky on Pompeii and other towns south of the mountain. Many of that city's inhabitants seem to have been deluded by the initially light fall of ash into believing that they could survive by simply taking cover indoors. That misjudgment caused at least two thousand of them to be asphyxiated early the following morning by the first of six hot, dust-laden clouds (so-called *nuées ardents*, burning clouds) that traveled down the mountain at a speed calculated to be more than a hundred miles an hour. Shortly thereafter, their bodies were buried under layers of ash and pumice 20 to 26 feet deep that entombed Pompeii, leaving only the tops of the tallest buildings visible.

VOLCANIC DEVASTATION Herculaneum, located further north between two streams that flowed down the slopes of Vesuvius, was spared the deluge of pumice and ash during the early hours of the eruption, but

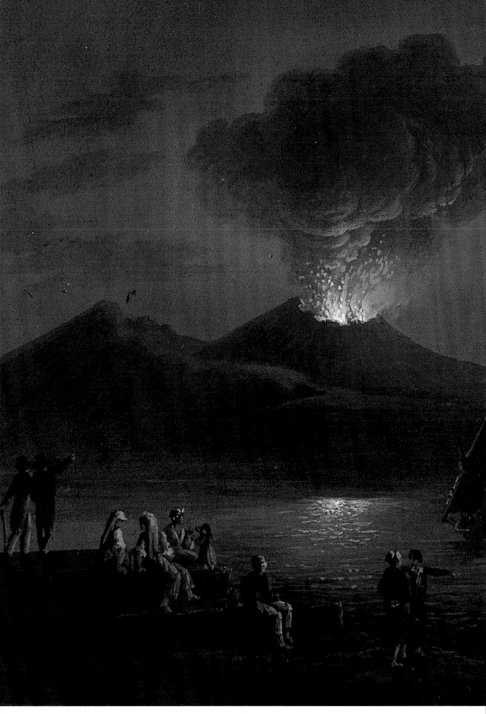

■ Michela de Vito (Italian, 1808–1867), *Eruption of Vesuvius 21 March, 1828,* 1828–1835. Detail. Gouache. GRI no. 980046.

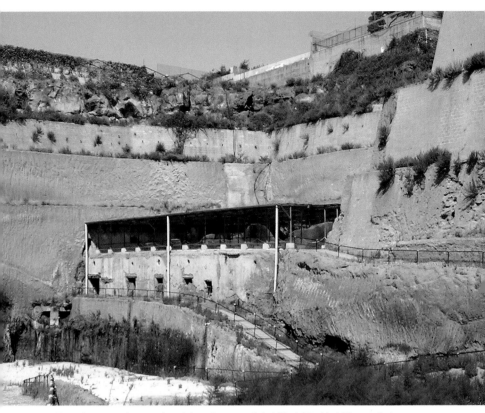

■ Modern open-air excavation of the atrium area of the Villa dei Papiri vividly reveals the great depth of the layers of debris that buried the building. The corrugated roof protects the ancient floors and walls. The openings beneath the atrium are newly discovered entrances to rooms at a lower level.

was suffocated and buried by the sudden series of hot, poisonous ash-laden clouds, or surges, alternating with volcanic flows that began around midnight. Such pyroclastic flows are high-density mixtures of hot, dry rock fragments and hot gases that rush away from the eruption at high speeds. They typically consist of two parts: a basal flow of coarse fragments that moves along the ground, and a turbulent cloud of ash that rises above the basal flow. With rock fragments ranging in size from ash to boulders traveling across the ground at high speeds, pyroclastic flows knock down, shatter, bury, or carry away nearly all objects and structures in their way. The extreme temperatures of rocks and gas inside these flows—generally between 400°F and 1300°F—cause combustible material to burn, especially wood and vegetation. Death and serious injury to people and animals result from burns and inhalation of hot ash and gases. The flows sear flesh and may literally make blood boil. Eventually, however, the masses of steam emitted by the volcano condense, causing torrential rains. These fell along

the west slopes of Vesuvius with the result that Herculaneum was encased in a flood of mud.

As few human remains were found at Herculaneum, it was long believed that most of its inhabitants had time to flee. But the discovery since 1982 of some 300 skeletons at the base of a cliff facing the sea, some clutching lamps and precious gold jewelry and tumbled together as if in a panic, suggests that many who had sought to escape were asphyxiated in boathouses on the beach, trapped between the deadly volcanic surges and the sea, while awaiting rescue by ship. Some buildings collapsed from the speed and force of the surges, while others were hermetically sealed by volcanic matter that seeped in without disturbing the smallest or most fragile items. Further surges buried Herculaneum and the nearby Villa dei Papiri under an almost impenetrable rock-hard cover, which, following subsequent eruptions, notably in 1631, is now between 65 and 100 feet deep.

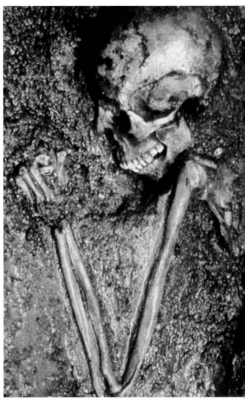

■ Recent excavations at Herculaneum have uncovered hundreds of skeletons, like this one, of people who had gathered their valuables and fled to the beach. There they huddled in boathouses, hoping in vain to be rescued.

EYEWITNESS ACCOUNTS In A.D. 79 the Roman military commander and natural historian Pliny the Elder (Gaius Plinius Secundus) was living at Misenum on the northwestern edge of the Bay of Naples, where he commanded the Roman fleet. Born in Como in northern Italy and trained as a lawyer and orator, Pliny served in the army in Germany and went to Spain as revenue collector under Emperor Vespasian before becoming a military prefect under Titus. Informed by his sister that "a black cloud of extraordinary dimensions and appearance" had risen above the volcano, Pliny resolved to investigate this remarkable phenomenon and, having received a worried note from friends living closer to the volcano, he set out, in his capacity as commander of the fleet, to rescue anyone in danger along the coast. Sailing across the Bay of Naples, through falling ash, pumice, and

cinders, Pliny kept his cool and dictated his observations to his secretary. Years later these were reported by his nephew and adopted son, Pliny the Younger, to the historian Tacitus, and alongside evidence from modern excavations and comparisons to more recent eruptions, such as those of Mt. St. Helens in 1980 and Mt. Pinatubo in 1991, they have allowed modern vulcanologists to reconstruct the sequence of the eruption of A.D. 79.

Pliny attempted to land at Herculaneum, but the sea was too rough, so he went further south to Stabiae, where the danger "was not yet immediate, though very near and very evident as it increased." There he hoped to relieve his companions' fears by declaring that the great flames visible in the distance "were merely fires in villas deserted by their peasants." He bathed and dined with friends, but was unable to sleep throughout the night, as the fall of ash was so heavy that it began to block doorways and passages of the house. The walls, meanwhile, were shaken by repeated violent shocks. As pumice continued to rain from the sky, Pliny and his friends tied pillows to their heads and went out into the dawn, which, however, "seemed blacker and denser than night ever was." Reaching the sea, they found the waves too tumultuous to sail. It was there on the beach at Stabiae, on the second day of the eruption, that the elder Pliny, who was not in the best of health, died.

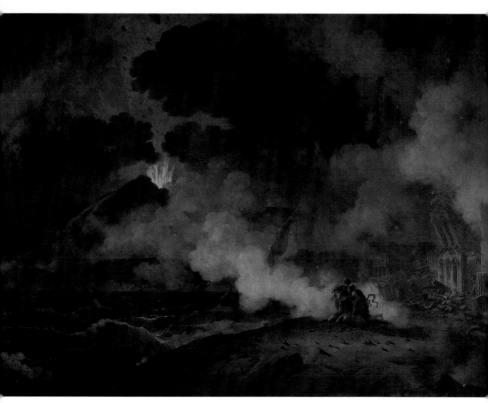

■ Pierre Henri de Valenciennes (French, 1750–1819), *Eruption of Vesuvius on August 24*, A.D. 79, 1813. Oil on linen, 147.5 x 195.5 cm. Toulouse, Musée des Augustins, inv. 7811.

Twenty-five years later, Pliny the Younger, who had remained behind with his mother at Misenum, thirty miles away, wrote two detailed letters to Tacitus. One describes his uncle's death and the other relates his own experiences during the eruption. His eyewitness accounts bring the horror of this catastrophe to life even after almost two millennia:

> We encountered many weird and terrifying things. For instance, the vehicles which we had ordered, although they were standing in a level field, were rushing in various directions, and not even with the stones under their wheels would they remain in place. Then we watched as the sea was sucked back into itself, as though hurled back by the tremors of the land. Certainly the sea receded far enough to leave many marine animals stranded on the dry sands. From the other direction there rose a frightening black cloud broken by writhing, trembling, fiery spews; it gaped open from time to time to reveal flaming shapes. These were like bolts of lightning but were much larger.... Night settled on us, not of the moonless or overcast sort, but one like a light suddenly gone out in a very small confined place. You could hear women shrieking, children screaming, men shouting.... Both the darkness and the great deal of heavy ash descended upon us once more. From time to time we had to stand up and shake the ash from ourselves, otherwise we would have been covered by it and crushed under its sheer weight." (*Letters* vi.20)

Thousands of people were buried in successive layers of volcanic matter.

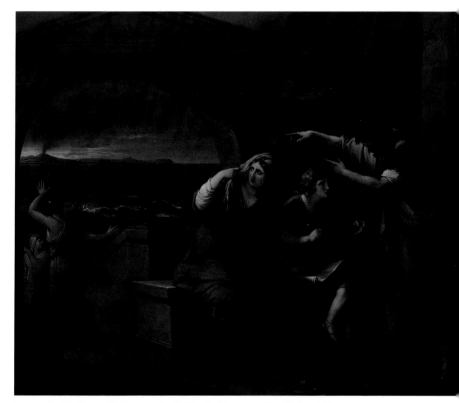

Angelica Kauffmann (Swiss, 1741–1807), *Pliny the Younger and His Mother at Misenum, A.D. 79*, ca. 1770. Oil on canvas, 103 x 127.5 cm. Princeton University Art Museum. Museum purchase, gift of Franklin H. Kissner, inv. y1969-89.

When news of the eruption reached Rome, Emperor Titus dispensed aid to the survivors out of his private funds. He also sent search teams to Pompeii to unearth what valuables they could, but they were soon recalled to cope with the effects of a great fire in Rome. Robbers and looters then took over at Pompeii, gaining access to buried buildings—the tops of some remained visible—by sinking wells down through the relatively loose layers of ash and small pieces of lava, called lapilli, thrown out by the volcano during the eruption. From these wells the looters could move horizontally from room to room in the buildings.

Herculaneum, buried much deeper than neighboring Pompeii by solidified ash flows that are much more difficult to penetrate, largely escaped ancient treasure hunters. While the names of both cities survived in ancient literature, and rumors of hidden treasures at the foot of the volcano persisted in local lore, the locations of the ancient cities near Mt. Vesuvius were gradually forgotten.

EIGHTEENTH-CENTURY EXCAVATIONS Although antiquities seem to have been recovered haphazardly from the site since at least the Renaissance, the rediscovery of Herculaneum in the eighteenth century is a story of chance and treasure hunting. About 1709, a local landowner, Cola Anniello Nocerino, called Enzechetta, was deepening her well in the small fishing and farming village of Resina, the town that had been built on top of ancient Herculaneum (today the community is called Ercolano). She uncovered several fragments of colored marble that she sold to a marble worker, who alerted Emmanuel-Maurice de Lorraine, prince d'Elboeuf. The prince, an officer in the Austrian army attached to the Neapolitan court, was building a luxurious villa for his Italian bride at nearby Portici and, eager for more building material, he purchased Enzechetta's property from her son and arranged for further digging at the site.

For several years d'Elboeuf underwrote excavations that were carried out by means of subterranean tunneling. (Rather than expose the deeply buried site to the open air, which would have been prohibitively expensive, the excavators dug tunnels and backfilled them with unwanted material. This both avoided the difficulty of hoisting cleared debris to the surface and helped to prevent collapses.) The colored marble wall facings, columns, and sculptural fragments that were brought to the surface were used in the construction of the prince's villa. When complete statues began to emerge, however, the project took a new direction: the recovery of works of art. Three life-size marble statues of women were the most significant finds. Bypassing a law forbidding the export of antiquities, the prince smuggled the three statues out of Italy and sent them to his commander-in-chief, the Austrian general Prince Eugène of Savoy in Vienna.

After Prince Eugène died in 1736, the statues entered the Dresden collection of Frederick Augustus, Elector of Saxony, who owned some of the finest classical sculpture outside Italy. His daughter, Princess Maria Amalia Christina, thus knew the statues from Herculaneum well, so when she came to Naples as the bride of Charles III, the Spanish Bourbon king, she encouraged her husband to resume the work d'Elboeuf had abandoned some twenty years earlier. Charles was tantalized by the prospect of ancient treasures that could make his court the richest in Europe, and in October 1738 digging was begun again. The king appointed Roque Joaquín de Alcubierre, a military engineer who had come to Italy with the Spanish army, to direct the project. In December of that year, a Latin tablet was excavated that finally identified the site beneath Resina: LUCIUS ANNIUS MAMMIANUS RUFUS HAS FINANCED THE CONSTRUCTION OF THIS BUILDING, THE THEATER OF HERCULANEUM.

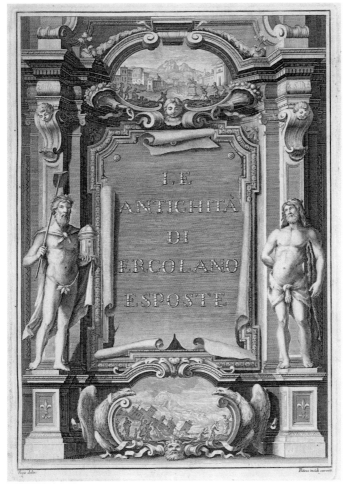

Title page of *Le antichità di Ercolano esposte,* 1757. Note the statues of Herakles at the sides and the images of the city before and after its destruction, above and below.

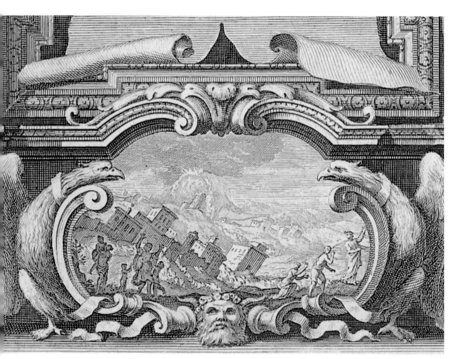

■ Detail of the lower vignette on the title page of *Le antichità di Ercolano esposte* (see p. 37) showing the destruction of Herculaneum as imagined in the eighteenth century.

Alcubierre was as enthusiastic at the prospect of spectacular finds as was his royal employer. He widened Nocerino's original well shaft and dug tunnels in all directions from it. Bronze and marble statues were wrested from the rock-hard ground and brought to the Royal Palace at Portici, where a museum was established for them. Unfortunately, few records were kept of individual discoveries, and only undamaged finds considered to have artistic merit were kept. Many imperfect marble or metal objects were discarded or melted down for reuse. In his haste to enrich the king's museum, Alcubierre is reported to have ripped bronze letters from walls without first recording the inscriptions they formed. Charles III considered Pompeii and Herculaneum to be his private property—he was, after all, paying for the excavations—and he jealously limited access to the museum at Portici. But requests for news about the discoveries from the two ancient cities increased, and so in 1755 he established the Accademia Ercolanese di Archeologia to study and publish information about the finds at both sites. The academy, however, was doomed from the start by jealousy and intrigues among its members, and it accomplished very little. Yet it was a beginning, for engravings of the most important wall paintings discovered during the excavations were published by the royal press in 1757 in the first of eight volumes entitled *Le antichità di Ercolano esposte* (On the antiquities of Herculaneum).

Only a hundred copies were printed of this first volume, intended strictly for distribution by the king, but pirated editions in English, German, and French soon were circulated, thus making Herculanean and Pompeian motifs accessible to a wider audience.

DEVELOPMENT OF NEOCLASSICISM In the mid-eighteenth century such publications were eagerly sought after, for the discovery of Herculaneum and Pompeii (first brought to light in 1748) inspired a new appreciation for classical styles and had a profound impact on European cultural life. The fascination with antiquity that had originated in the Renaissance received new impetus during the Enlightenment and became the catalyst for the development of Neoclassicism, which spread across Europe with remarkable speed. The artists, writers, and composers of this period revered antiquity as a time of perfection in art and design. Antique models inspired changes in eighteenth-century decorative arts, painting, architecture, dress, and jewelry. For example, the Englishman Josiah Wedgwood used decorative motifs from antiquity on the ceramics he produced in his factory, and in France the Sèvres manufactory reproduced "Pompeian" wall paintings on its porcelains. Decoration *à la grecque* came into vogue in Paris, where the ornate curves of the Rococo period were replaced by rectilinear forms and classical symmetry. The popularity of the Neoclassical style in America is evidenced, for example, by Thomas Jefferson's decision to build Monticello as a classical revival building.

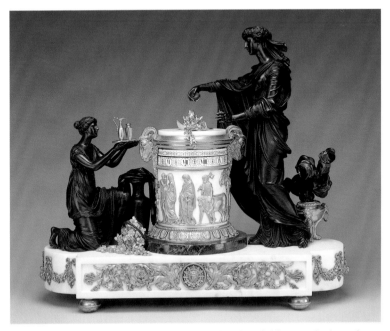

■ This elaborate gilt bronze and marble Neoclassical clock, intended for a mantle piece, takes the form of a Roman priestess and servant girl making offerings at the altar of Vesta, Roman goddess of the hearth. J. Paul Getty Museum, 82.DB.2.

Engraving showing the antiquities of Herculaneum and Pompeii being transfered in 1778 from the museum in Portici to the then newly established museum in Naples, where they remain to this day. From Jean Claude Richard de Saint-Non, *Voyage pittoresque, ou, Description des royaumes de Naples et de Sicile* (Paris, 1781–1786), vol. 1.2, no. 95.

A visit to Italy, its excavations, and—if possible—the royal museum at Portici became a must for every student, artist, and tourist. Already in 1749, Madame de Pompadour, mistress of King Louis xv, had organized a tour of Italy for her brother in order to further his artistic education. In his entourage was the artist Charles-Nicolas Cochin. Although he visited the Portici museum, Cochin was not allowed to make any drawings while there. However, some of his illustrations made from memory were reproduced in his *Lettre sur les peintures d'Herculanum* (Letter on the paintings of Herculaneum) published in 1751, which gave the French their first glimpse of the treasures, and more appeared three years later in a small book, *Observations sur les antiquités de la ville d'Herculanum* (Observations on the antiquities from the town of Herculaneum), which was so popular that it went through several editions and was soon translated into English.

In 1758 another important visitor came to the museum: the German art historian Johann Joachim Winckelmann. After his second visit in 1762, Winckelmann was annoyed by restrictions precluding sketching and note-taking, and he wrote a highly critical letter to his German patron, which was published in multiple languages. His comments earned him the wrath of the Neapolitan court: using an Italian proverb, he wrote that Alcubierre "knew

as much of antiquities as the moon does of lobsters." But Winckelmann's observations about antiquity helped to earn him a firm place in the history of art. He is credited with being the first to classify the archaeological finds and to distinguish between Greek works and Roman copies. By applying methods of historical research to ancient art, he helped to lay the foundations of modern art history. As an alternative to the amassing of ancient objects merely to increase the status of noble patrons, Winckelmann proposed that such objects be studied as expressions of Greek and Roman culture and customs. In the process he opened up antiquity for the eighteenth century and helped to inspire the Neoclassical movement. Although some modern scholars have been critical of Winckelmann, the slightly younger German poet Johann Wolfgang von Goethe wrote that he was "like Columbus who had in his mind a notion of the New World before he actually saw it."

Goethe himself was among the many travelers who flocked to Naples at the end

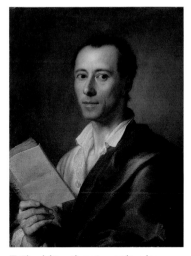

■ The eighteenth-century antiquarian Johann Joachim Winckelmann was instrumental in disseminating information about the discoveries at Herculaneum. Anton Raphael Mengs (German, 1728–1779), *Portrait of Johann Joachim Winckelmann,* shortly after 1775. Oil on canvas, 63.5 x 49.2 cm. New York, The Metropolitan Museum of Art, Harris Brisbane Dick fund 1948, 48.141.

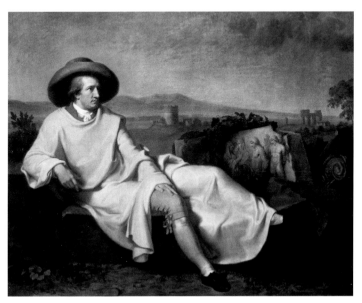

■ Johann Wolfgang von Goethe shown against a backdrop of classical antiquities. Johann Heinrich Wilhelm Tischbein (German, 1751–1829), *Goethe in the Roman Campagna,* 1787. Oil on canvas, 1.64 x 2.06 m. Frankfurt, Städelsches Kunstinstitut, inv. 1157.

of the eighteenth century to admire the relics of the ancient past. Of the museum at Portici he remarked, "That museum … is the alpha and omega of all collections of antiquity; there you see right clearly how far ahead of us the ancient world was in the joyous sense of art, if in skill in handicrafts in the strict sense it was much behind us." The finds that emerged from the glorious past of Campania did not always measure up to that evaluation, however. Erotic art found there was considered so shocking that it was hidden away in a "secret" room in the royal museum, accessible only to those who obtained a special license signed by the king. But, as Winckelmann wrote, no one wanted to be the first to ask. The seeming lack of artistic merit of many of the finds, particularly the wall paintings, also aroused puzzled curiosity. In fact, this "lack" was often due to their less-than-perfect state of preservation.

VILLA DEI PAPIRI DISCOVERED Although excavation work continued at Herculaneum under the direction of Alcubierre, after 1748 he focused most of his attention on the newly discovered Pompeii, where the king had also given him permission to dig. By 1750 Alcubierre's obligations as a lieutenant colonel required him to move to Naples, and he requested that someone else be appointed to oversee the work under his supervision. Shortly before the arrival of this new overseer—Karl Weber, a Swiss engineer, who had worked for Charles III since 1735—well diggers working in a garden near the Herculaneum excavation struck some fragments of ancient colored marbles. Excavation at the site was especially difficult because of the density of the volcanic matrix and the depth, some eighty feet below ground level,

■ This illusionistic circular marble floor from a belvedere, now in the National Museum in Naples, was the first part of the Villa dei Papiri to be discovered, in August 1750.

as well as the constant seepage of water into the tunnels. To continue the work, it was necessary to sink a second shaft for an air pump, bucket, and additional winch cables. At a depth of a hundred feet, workers found an elaborate circular marble floor that adorned the belvedere of a villa. The floor, lifted out piece by piece and reassembled at Portici, marked the discovery of the Villa dei Papiri.

Throughout his years of overseeing the excavation work at Herculaneum, Weber filed weekly progress reports to Alcubierre. These reports indicate that their relationship was strained by the

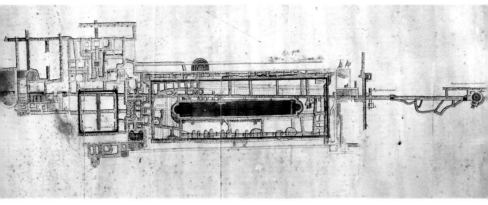

■ Weber's plan of the Villa dei Papiri and the tunnels his workmen dug to explore it is the most complete record of the ancient building, the bulk of which remains underground. The plan is oriented with the Villa building to the left and outer peristyle to the right. The belvedere is at the extreme right.

conflict between Weber's systematic method of excavations, which earned Winckelmann's praise, and Alcubierre's less careful approach. Despite the latter's repeated exhortations to get on with the search for art objects, Weber took the time to make several drawings of the subterranean excavations, notably a detailed floor plan of the Villa dei Papiri. This plan, which included notes describing and locating specific objects discovered at the site, was later revised either by Weber himself or by his successor, Francesco La Vega. Without Weber's original rendering, however, there would be no systematic (if partial) record of the ground plan of one of the grandest ancient Roman villas and one of the greatest archaeological discoveries of the eighteenth century.

ATRIUM HOUSES The plan of the Villa dei Papiri as revealed by Weber shows the building to have conformed to the atrium house type that was common in Campania in the centuries before A.D. 79. Although the villa has not been fully explored, many other buildings buried along with it have been. From them a great deal has been learned about the houses of both patricians and plebians during this period.

Many people in Pompeii and Herculaneum lived in residential blocks with shops or taverns at street level and living quarters above. By the third century B.C., however, some wealthier citizens lived in single-family dwellings, each of which was built around a central hall called an atrium. The basic floor plan of the atrium house stressed symmetry and axiality. The entrance from the street led through a hallway (the *fauces*, or jaws) into the atrium, which was surrounded by small cubicles — *cubicula* — originally used for sleeping. An opening in the roof of the atrium, known as a *compluvium*, admitted light as well as rainwater, which was stored in the

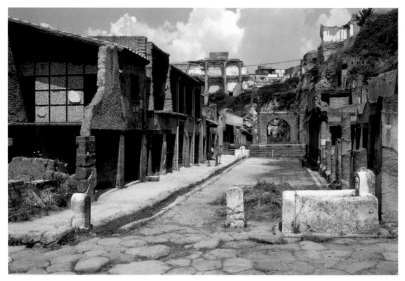

The *decumanus maximus,* the main east-west street, of Herculaneum. As is typical for the Roman towns in Campania, this residential block has shops at street level with living quarters on the floor above.

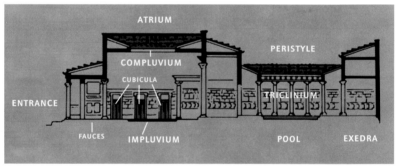

Schematic cross-section of a Roman atrium house.

impluvium, a basin or pool set into the floor under the opening. Often the water was fed into a larger cistern underground. The atrium was the public part of the house where business was conducted and visitors were received.

As time progressed, atrium houses became more lavish and varied in appearance. The old-fashioned walled gardens behind them were replaced by Greek peristyles, interior garden courts surrounded by colonnades. The private rooms, including the dining room (*triclinium*), bedrooms, and baths, now surrounded the peristyle, and the traditional, somewhat gloomy atrium, once the center of the home, gradually became a mere entrance hall.

The typical atrium house was oriented toward the interior and had few windows facing the street. All the rooms opened onto the atrium or peristyle garden, deriving indirect light from them—an advantageous use of light and

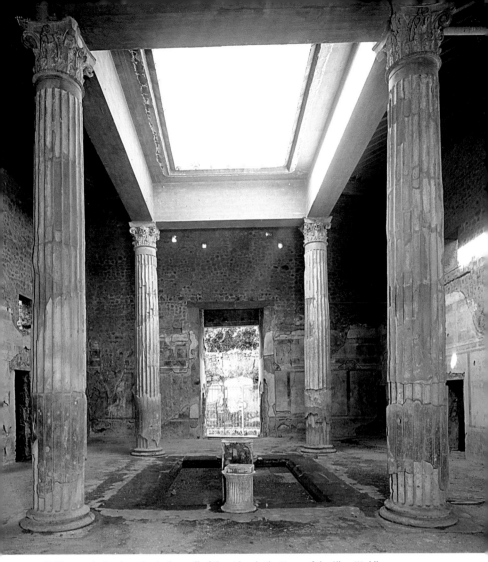

■ The *compluvium* (opening in the roof) of the atrium in the House of the Silver Wedding at Pompeii allowed both light and rainwater to enter the house. The water was collected in the *impluvium* (small pool) in the floor for use in the household.

shade in a hot climate. Seaside villas appear to have been an exception; contemporary Roman frescoes show them with colonnades and porticoes facing the sea, probably to take advantage of the views and the cooling sea breezes (see p. 91).

MARITIME VILLAS The Villa dei Papiri was a *villa maritima*, essentially an urban atrium house expanded and sited on the seaside as a retreat for city dwellers. The word *villa* originally referred to a rural dwelling run for agricultural profit by slave labor. Though an estate like the Villa dei Papiri, the full extent of which remains unknown, may have had a small working section, such as a wine press, houses of this type were more important to

Roman patricians as places of escape from the political and social tumult, from the demands of life in the capital. Cicero, for instance, mentions in his letters seeking solace at his villas, including one at Pompeii. Pliny the Younger wrote long, loving descriptions of the charm and beauty of his seaside villa at Laurentum, seventeen miles from Rome near the mouth of the Tiber, and of his villa in the Tuscan mountains, places where he could read and write in peaceful surroundings and entertain friends. These villas incorporated many features of the atrium house but on a grander and more elegant scale, and they often included several gardens like those found in the Villa dei Papiri.

The Villa dei Papiri evolved over almost three centuries. The original layout, with an atrium and rooms arranged around an intimate peristyle garden, probably dates to the early second century B.C. But as close scrutiny of Weber's plan shows, extensive changes, probably made in the first century B.C., expanded the original structure to create an extraordinary villa. A second peristyle, 348 feet long and 131 feet wide, was added to the west. Beyond that a terraced footpath led to the circular belvedere. In the center of the large peristyle was a pool 220 feet long and almost 24 feet wide—as large as some of the imperial baths later built in Rome. Such a large pool would have required a steady supply of water, and Weber reported finding a complex subterranean hydraulic system that fed the villa's pools, fountains, and baths with water from Herculaneum's aqueduct. The large pool was probably stocked with fish, a culinary delicacy enjoyed by wealthy Romans.

Karl Weber mined the Villa dei Papiri from 1750 to 1764. Three and sometimes as many as six tunnels were worked on simultaneously by half a dozen slaves or convicts doing forced labor. (Weber complained that the chains of the convicts assigned to him might damage the ancient mosaic floors and asked to have them removed.) From these explorations came an amazing trove of sculpture: at least eighty-five pieces—small, medium, and large bronzes and marbles, including several busts—more than from any other ancient building. Most of the busts apparently represented famous Greek military and civic leaders, philosophers, poets, and literary figures. Lifelike sculptures of animals, demigods, cupids with dolphins, and satyrs pouring water from wineskins surrounded the villa's large pool and the *impluvium* in the atrium. These statues, which are remarkably well preserved—a testimony to Weber's insistence on the careful chipping away of volcanic matter—are today displayed in the Museo Nazionale in Naples. The gardens of the Getty Villa contain modern replicas of many of them, placed, as much as possible, in the locations where Weber seems to have discovered them. (Unlike the ancient works of art inside the Museum's

■ The circular Corinthian colonnade of Villa Fersen in Capri is a stunning example of how ancient architects incorporated the beauty of the sky, the sea, and the landscape in general into the architectural whole.

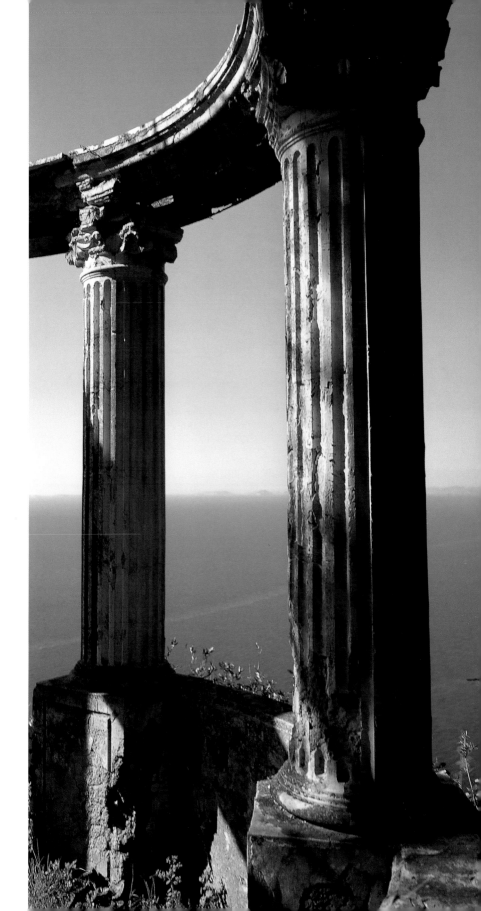

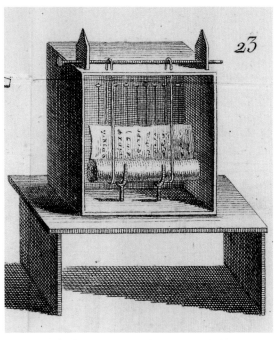

■ Engraving of wall-painting from Pompeii showing a woman reading a papyrus scroll. From *Delle Antichità di Ercolano*, vol. 4 (Naples, 1765), p. 305.

■ Extremely fragile, the papyrus scrolls were unrolled with the help of a specially designed machine. From Auguste-Denis Fougeroux de Bondaroy, *Recherches sur les ruines d'Hercula-neum ...* (Paris, 1770), pl. 2, fig. 23.

galleries, these copies remain exposed to the elements.) Some of the originals found in the Herculaneum villa, however, were evidently in the course of rearrangement after the earthquake of A.D. 62 or were displaced by the flow of lava in A.D. 79. Thus their exact arrangement cannot be determined.

PAPYRUS SCROLLS Of great interest to its eighteenth-century discoverers was the library of papyrus rolls that gave the villa its modern name. In a small room (not repli-cated at Malibu) upward of a thousand charred book rolls were found stacked on shelves and heaped on a central book stand. They were so badly burned that they were initially mistaken for small black bricks. The first attempts to unroll and decipher

■ When first uncovered, the charred papyrus scrolls from the Villa dei Papiri were not recognized as book rolls. Many were discarded as burnt wood.

the scrolls destroyed many of them. Thus Father Antonio Piaggio, a Genoese priest who had worked with Latin manuscripts in the Vatican library, was

■ Philodemos papyrus from the Villa dei Papiri.

brought to Portici in 1753 to try to unroll the papyri. The work was excruciatingly slow. After four years of experimentation, he had unwound only three of the fragile documents.

The first roll turned out to be a Greek treatise on music by the first-century B.C. Epicurean philosopher Philodemos of Gadara (a town near the Sea of Galilee). Fifty years later, only about a hundred of the scrolls had been deciphered. Today more than half have been read. Modern imaging technology has greatly facilitated the process. The fact that most of the texts are by Philodemos has been a disappointment to many classical scholars, who hoped that the texts would include long-lost works by the great Greek and Roman poets, dramatists, philosophers, and historians. One expert has described Philodemos's works as "pedestrian in style, earnest in tone, uninspired, though not uninteresting in content." As the vast majority of the scrolls contain Greek texts—a fragment of a Latin poem celebrating Octavian's victory over Antony and Cleopatra is an exception—it is possible that a second library of Latin literature might still be buried in the unexcavated part of the

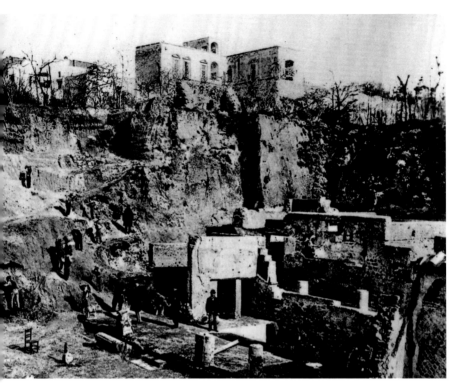

■ Starting in 1828, efforts were made to excavate Herculaneum by removing the overburden. This photo, from the second such campaign, in 1869, shows the ancient buildings laid bare in the foreground. The modern buildings look down from the edge of the excavation. From Amedeo Maiuri, *Herculaneum* (Paris, 1932), p. 10.

villa, for Roman owners of Greek and Latin libraries often housed the two separately. As it is, the extant library is the only ancient library whose contents have survived together in any condition.

The large number of scrolls by Philodemos found in the library of the Villa dei Papiri link it to the wealthy Roman consul Lucius Calpurnius Piso Caesonius, the father-in-law of Julius Caesar, who is known to have been Philodemos's patron (and, as we have seen, was a protagonist in J. Paul Getty's novella, *A Journey from Corinth*). Cicero wrote disparagingly about the close relationship between Piso and Epicurean philosophy, and in a surviving poem, Philodemos addresses his patron and describes himself as Piso's friend. It may have been Piso's son, L. Calpurnius Piso Pontifex, who was responsible for the expansion of the Villa dei Papiri at the end of the first century B.C. We know nothing, however, about the villa's owner at the time of Vesuvius's eruption. Certain features, including a large amount of grain stored in some of the rooms, suggest that the building may have been undergoing a transformation from a deluxe country house to an agricultural villa when the volcano exploded, but such distinctions are, perhaps,

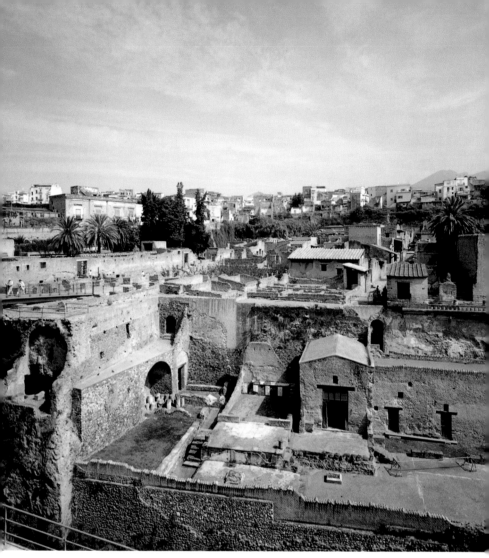

■ Today some of Herculaneum has been excavated. The surrounding modern town still looks down on the ancient city, and Vesuvius still rises behind both.

anachronistic. The presence of several lime tubs, however, implies that the building may have been under repair, perhaps as a result of the damage from the earthquake in A.D. 62.

EXCAVATION DIFFICULTIES AND PROGRESS By 1761 exploration of the Villa dei Papiri had virtually stopped. The inhabitants of Resina regularly complained that their houses were developing cracks or even collapsing into the excavation tunnels that had undermined their foundations. Support columns in the tunnels partly alleviated this problem, but there were not enough of them. Furthermore, the seepage of water and poisonous gases from the volcanic rock made underground work dangerous. The tunnels were backfilled, and the wells were sealed in 1765.

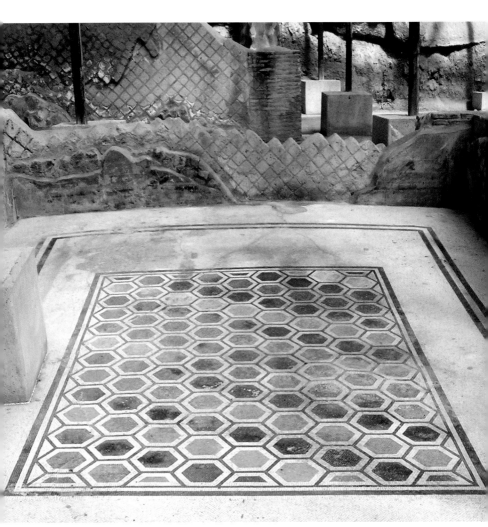

■ The recent excavations of the Villa dei Papiri have revealed frescoes on walls and colorful geometric-patterned marble and mosaic floors such as this one in a room just off the villa's atrium.

As the flow of spectacular finds dwindled and excavation problems increased, work at other sites in Herculaneum was also abandoned, but in 1828 excavations were revived and, for the first time, complete removal of the thick, rock-hard volcanic deposits was attempted. But the work was difficult, and only two of the ancient city blocks were exposed. In the late 1860s, under the auspices of the Italian king Victor Emmanuel ii, two more blocks were uncovered. Work was discontinued, however, when the excavators approached the houses of modern Ercolano, and local landowners once again objected. In 1927 the landowners received compensation from the government of Mussolini, who supported new archaeological explorations.

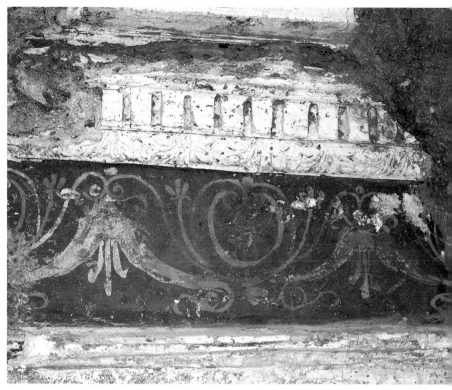
■ This section of a wall newly excavated at the Villa dei Papiri preserves both a colorful painted floral frieze and plaster decoration in relief.

Today in Herculaneum, where as much as half of the city remains buried, digging continues, facilitated by the use of compressed-air drills and the presence of experts in conservation.

At the site of the Villa dei Papiri, in the late 1980s and 1990s excavators not only cleared the debris from many of the early access wells and tunnels dug by Weber's workmen in the eighteenth century but they also removed the heavy overburden of volcanic material over the southwest portion of the building, bringing some of the atrium and surrounding cubicula to light for the first time in almost two millennia. These rooms have rich mosaic and terrazzo floors, and remains of frescoed walls have also been found. Below the atrium investigators discovered a second story of rooms with glass windows and frescoed walls. There are also traces of a third story above the atrium, and perhaps a fourth, further below, for the villa was a multistory building constructed on a series of terraces. The much-hoped-for Latin library, however, has yet to appear, and the vast majority of the building remains buried.

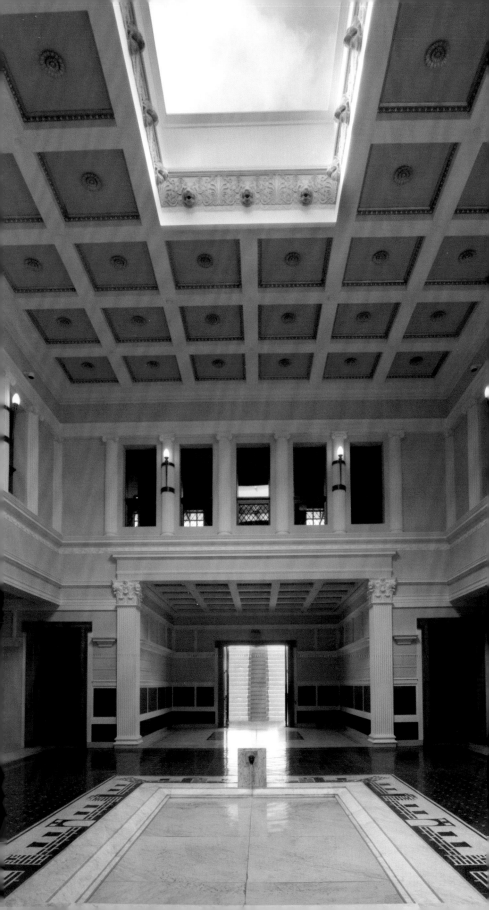

A Walk through the Getty Villa and Its Gardens

HE SIZE AND DESIGN of the Getty Villa follow Karl Weber's plan closely, but not exactly. The canyon topography of the Malibu site required the reorientation of the building, with the long axis perpendicular, rather than parallel, to the coastline. The layout of the Museum is essentially the same as that of the buried original: a large, two-story main block with an atrium, an adjacent inner peristyle with a garden and a *triclinium*, and a vast 348-foot-long outer peristyle with colonnades, frescoed loggias, garden, and fishpond. The Atrium and Inner Peristyle, however, have been repositioned in Malibu. The fishpond in the Outer Peristyle is substantially shallower than the original. And the circular belvedere first discovered in 1750 has been omitted, as have the villa's bath complex and library. Moreover, because Weber's plan is incomplete, many details of floors, walls, ceilings, and decor at the Getty Villa are based on information gleaned from Campanian and Roman villas and houses other than the Villa dei Papiri. These details evoke the kind of secluded, private environment in which the patrician owner of a Roman villa would have enjoyed and displayed his possessions. Some features of the Museum's design were also dictated by the needs of a modern exhibition space. When the Malibu Villa was constructed

■ The *compluvium* in the ceiling of the Atrium of the Getty Museum has been opened to the sky and the *impluvium* in the floor is filled with water, just as in ancient Roman villas.

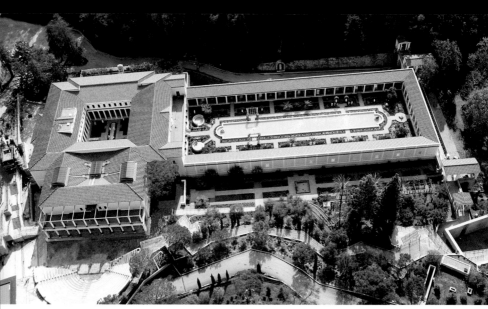

Aerial view of the Getty Villa from the west. The Museum Path at the bottom of the photograph leads to the Barbara and Lawrence Fleischman Theater in the lower left corner.

in the early 1970s, an upper story was added to provide more gallery space, despite the absence at the time of certain evidence for its existence in Herculaneum. Since then, archaeologists have found traces of water pipes leading upstairs, overlooked by Weber, confirming that the Villa dei Papiri, too, had an upper floor. They also uncovered evidence for at least one lower level.

To re-create the atmosphere of a Roman villa successfully, the landscaping of the grounds had to be planned and executed as carefully as the building. Gardens were an important component of a Campanian property: often house and garden were so closely integrated that it was hard to tell where one ended and the other began. Excavations at Pompeii and Herculaneum have shown that in the first century A.D. even the most humble house had a garden, a small walled-in space in which to grow herbs and greenery. Shade as well as food might have been provided by fruit trees. And many plants had mythical associations as well as culinary, medicinal, aromatic, chromatic, and magical uses. Roman homeowners worked, played, ate, and relaxed in their gardens, which were meant to catch cooling breezes and make the most of pleasant vistas. The garden decoration of grander houses often included representations of woodland creatures—the god Pan, satyrs, and nymphs—in the form of sculptures and frescoes. Peristyles, fountains, and pools were also common in larger gardens.

The re-creation of a Roman garden in Malibu was a challenging but feasible undertaking due to the similarity between the climates of Southern California's coastline and the Bay of Naples. Although we do not know what specific plants grew in the gardens of the Villa dei Papiri, Roman literature

and wall paintings from Pompeii and Herculaneum (together with scientific analyses of carbonized roots, seeds, fruits, vegetables, nuts, and woods from more recent excavations) provide general information about landscaping fashions and the plants the Romans used and enjoyed. For the Museum's plantings, many seeds and bulbs were imported from Italy and acclimatized in a local nursery. Evergreens were chosen to be predominant just as they were in Roman formal gardens; these include laurel, box, myrtle, ivy, and oleander. Although roses, lilies, violets, daisies, irises, and other flowers were planted for seasonal color, the overall impression made by the Museum's gardens is one of lush, but controlled greenness.

ENTRY AND ENTRY PAVILION

From the double-arched entrance gates just off the Pacific Coast Highway, the Museum's access road, paved to imitate the polygonal flag-stones used in the streets of Herculaneum and throughout the Roman Empire, ascends through a grove of native sycamore, pine, eucalyptus, and coast redwood to the imposing, two-story south facade of the Villa, which stretches like a bridge across the narrow canyon. The upper level, which is

■ The Entry Pavilion, which visitors pass through on their way from the parking structure (center top) to the Museum Path. The Pacific Ocean is visible in the distance.

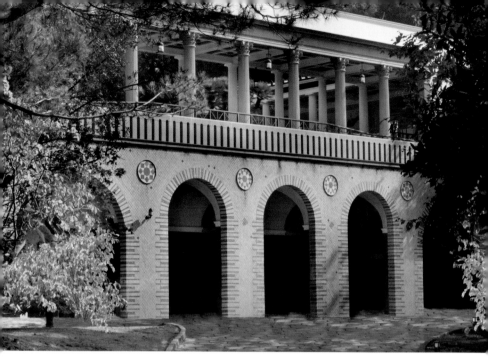

The elegant portico of Corinthian columns at the southern end of the Outer Peristyle rests on powerful supporting arches that together form the south facade of the Getty Villa.

stuccoed and painted, consists of a Corinthian colonnade flanked by windows with grilles and topped by pediments. Above are laurel wreaths in stucco relief modeled on such a detail from the House of Loreius Tibertinus at Pompeii. They recall the Roman *corona civica,* a potent symbol awarded to citizens who had done worthy deeds on behalf of their city. To the sides are two towerlike structures, the East and the West Belvederes, and beyond them, two small temples. Below, a series of arches, faced with square bricks of buff-

A *corona civica*—the laurel wreath awarded to Roman citizens for worthy acts—above a door at Pompeii. The wreath is replicated above the windows next to the towers of the south facade of the Outer Peristyle.

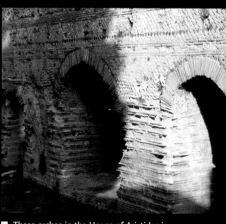

These arches in the House of Aristides in Herculaneum were the models for the arches supporting the south facade of the Outer Peristyle.

colored imported Italian tufa and dark lava from the Bay of Naples, shows
how ancient walls looked before stuccoing. Many of the buildings preserved
in Herculaneum and Pompeii have a similar appearance today as their stucco
facings have fallen off. The reticulated brickwork and ornamental inlaid
disks on the lower walls are copied from Pompeian shops, and the checker-
board pattern is from the Central Baths in Pompeii. The semicircular cast-
stone reliefs of griffins in the arched entrance doorways are based on a
similar design in the House of the Griffins on the Palatine in Rome, and a
motif from the same house decorates the ceilings within the doorways. The
design of the semicircular grilles above the other door openings is based on
motifs of the inlaid decoration of a tomb in the necropolis of Rome's port,
Ostia. This substructure, for which there was no evidence at Herculaneum in
the early 1970s, supports the Outer Peristyle and was necessitated by the con-
siderable downward slope of the Malibu site toward the sea. Recent excava-
tions, however, have revealed that the original Villa dei Papiri, too, was
supported on a series of terraces.

To the left (west) of the south facade of the Outer Peristyle is the new
Entry Pavilion. Here are orientation displays, an information desk, a parcel
check, and restrooms. A stairway and elevators lead up to various levels
of the Villa site and to the new Museum Path to the Barbara and Lawrence
Fleischman Theater and the Museum Entrance. The Entry Pavilion is con-
structed of banded concrete and stone walls that recall the strata of an
excavation. From the upper level, visitors have a stunning view of the Pacific
Ocean. From here a garden path, carved out of the hillside, as if part of a
modern excavation, leads along the edge of the site, providing a fine view of
the Museum and its Herb Garden below.

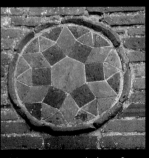

■ Typical Roman brickwork known as *opus reticulatum* from
the Central Baths in Pompeii (left). Such brickwork was often
stuccoed and painted, but it might also be left exposed, as it
is on the lower southern facade of the Outer Peristyle. The
starburst insignia on the wall of a house in a side street of
insula IV in Pompeii (right) is reproduced between the arches
of that facade.

■ This inlaid decoration on a tomb
in the necropolis of Porta Romana
in Ostia was the inspiration for the
decorative cast-stone grilles above
the doors and windows under the
Outer Peristyle.

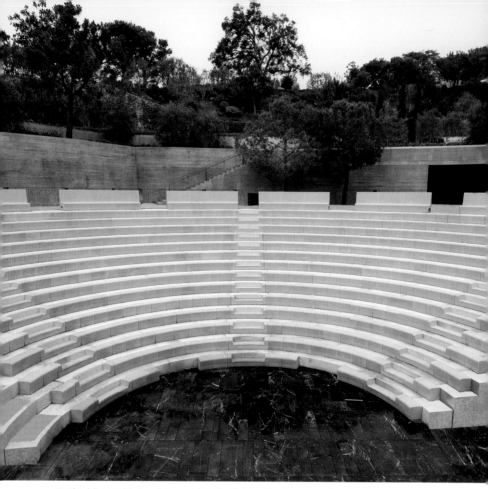

The rising semicircles of stone seats in the Outdoor Theater as seen from the stage area. The theater provides an outdoor setting for performances of concerts and ancient plays.

The Villa's theater imitates ancient theaters, such as the Odeon at Pompeii.

The Museum Path leads to the top of a small open-air theater, named for Barbara and Lawrence Fleischman. Carved into the hillside, it is inspired by the architecture of classical antiquity and designed after careful studies of original Greek and Roman theaters in the Mediterranean. Performances produced here offer modern audiences an experience of sound, sights, and intimacy comparable with those of ancient theater, but achieved by means of a contemporary vocabulary and providing modern standards of comfort and accessibility. The Theater consists of fifteen rows and seats an audience of 450 for concerts and performances of ancient drama (both comedy and tragedy) that are occasionally staged here.

There is a strong connection between ancient art and theater. Ancient dramatic performances drew on themes of mythology and history familiar to their audiences and inspired artists with their lively and provocative subjects. Many works of art housed in the Museum reflect this interest, not only by depicting Dionysos, the god of theater (as well as wine), but also by showing actors, stage sets, theatrical paraphernalia such as masks and costumes, and episodes from ancient plays. The Theater Plaza also provides a natural meeting place for visitors to gather and enjoy the surroundings.

The Museum's west facade serves both as the backdrop to dramatic productions and as the main entrance to the building. The facade consists of eight complex Corinthian columns flanked by two pilasters. The unusual form of the columns—with fluting of the lower third filled in, to avoid chipping of the rather fragile ridges between the recesses, and spiraling above (alternating in direction from one column to the next)—is modeled on columns found at the sumptuous Villa San Marco at Stabiae. The floor is paved with brilliant white Carrara marble, while the wall is painted with faux polychromed stone blocks, in the First Style of Pompeian wall painting. Bronze lamps, copied after an example excavated on the Via dell'Abbondanza at Pompeii alongside victims trying to flee the eruption, hang in the intercolumniations here, on the less ornate West Balcony above, and in the Outer Peristyle. These are adaptations of a type of lantern carried through the dark Roman streets; there were no public streetlights in antiquity. The ceiling of the lower colonnade is more of a modern fantasy, representing a view of the sky as if seen through a decorative openwork structure with flying birds and a shower of flowers in the circles. This motif was suggested by a fragment from the Villa of Arrius Diomedes at Pompeii, and the concept is also known from literary sources: the most famous example is the story told of the mad emperor Elagabalus, who caused roses to fall from an opened ceiling onto his guests at a banquet until they were all suffocated!

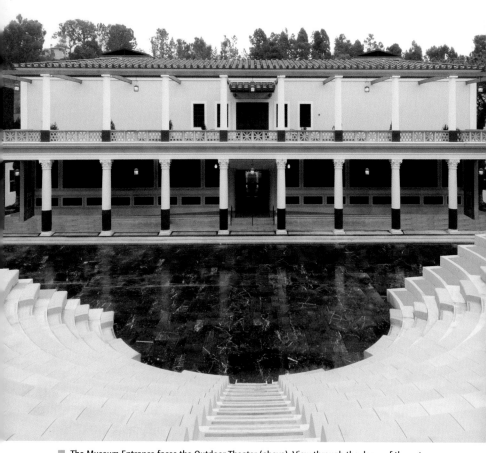

■ The Museum Entrance faces the Outdoor Theater (above). View through the doors of the entrance clear through the Atrium and Inner Peristyle to the East Garden of the Villa (right).

■ The lamps that hang here and elsewhere in the Villa are copies of examples found at Pompeii (far left). From *Delle Antichità di Ercolano*, vol. 8 (Naples, 1792), facing p. 263. The spiral columns of the Museum Entrance are modeled on columns found in the Villa San Marco at Stabiae (near left). The Romans often used shallower and less elaborate fluting on the lower parts of columns, where they are more prone to accidental damage.

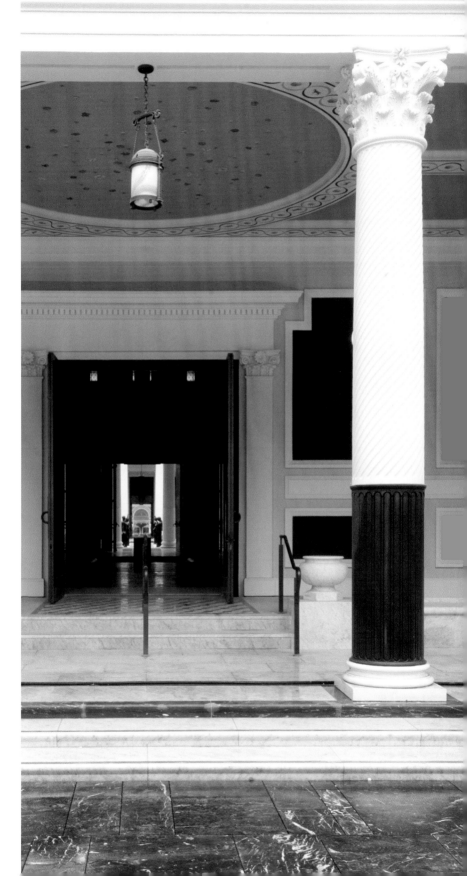

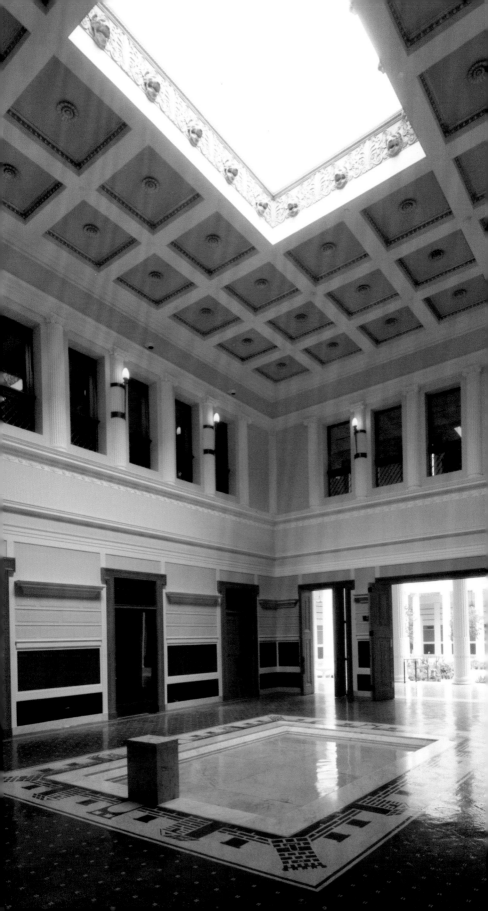

Two bronze doors lead from the Museum Entrance via a vestibule into the Atrium, the heart of the Roman house. The vestibule and Atrium walls are decorated in the First Style of Roman wall painting, resembling colored stone blocks. They imitate stonework in the atrium of the House of Sallust in Pompeii. The small Ionic half-columns above the projecting molding in the vestibule (see p. 67) are copied from the House of the Ship Europa in Pompeii. The stone floor of interlocking perspectival cubes in the vestibule is modeled on a floor in the House of the Faun at Pompeii. The Atrium proper is two stories high, as were the atria of many second-century-B.C. houses. The upper walls consist of a loggia of larger Ionic half columns that flank windows with bronze latticework parapets, all above a delicate floral border in plaster. These features are modeled on the atrium of the House of the Samnites in Herculaneum. The coffers in the ceiling have moldings and rosettes covered in gold leaf based on paintings in the House of the Lararium in Pompeii, and the Villa's open *compluvium* differs from its ancient models in that it can be closed by a mechanical shutter. (In antiquity *compluvia* sometimes had metal grilles to keep out nimble thieves.) The floral frieze with lion-head drain spouts is copied from a similarly positioned example in the House of the Vettii in Pompeii, but the lion heads themselves are inspired by fifth-century-B.C. examples from Metapontum in southern Italy. They were originally designed to channel rainwater off the roof into the marble *impluvium* below, and thence into a subterranean cistern. This system was at

■ The atrium was the center of a Roman house (left). The *compluvium* (opening in the roof) admitted light and water, which was collected in the *impluvium* (basin in the floor).

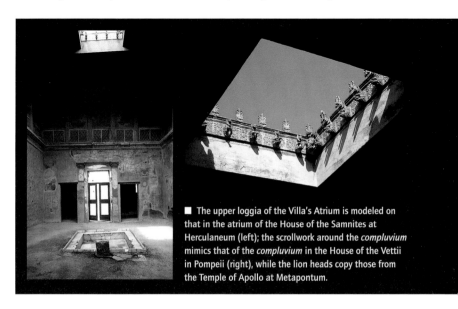

■ The upper loggia of the Villa's Atrium is modeled on that in the atrium of the House of the Samnites at Herculaneum (left); the scrollwork around the *compluvium* mimics that of the *compluvium* in the House of the Vettii in Pompeii (right), while the lion heads copy those from the Temple of Apollo at Metapontum.

one time the principal source of water for the household, but the introduction of concealed subterranean aqueducts and an ingenious hydraulic system supplying water to houses and fountains made these pools largely obsolete as reservoirs, and they were turned into decorative fountains. Here the basin is fed by a civet-head spout set into the marble pedestal.

More than a dozen bronze figures were recovered from the atrium of the Herculaneum villa. In Malibu, copies of four small boys, two with vessels and two with theatrical masks, adorn the corners of the *impluvium*. (Originally there were eight.) Bronze busts of Hellenistic rulers have likewise been placed near where Weber found some of the originals. Such personages seem to have offered ancient Romans models for emulation. Elsewhere in the villa, portraits of poets and philosophers and other works of art alluded to the owner's familiarity with Greek culture.

The atrium and some of the rooms surrounding the inner peristyle of the Villa dei Papiri had mosaic floors. In the Museum, only the Atrium has a mosaic floor. (Others are terrazzo—as at the Villa dei Papiri—marble, and wood.) One excavation report describes the mosaic in the atrium of the Herculaneum villa as showing "in various colors some towers and other structures." This mosaic cannot be identified today, so in Malibu the mosaic that surrounds the *impluvium* is modeled after another ancient black-and-white mosaic pavement, found in the Villa of Arrius Diomedes in Pompeii, that corresponds to the eighteenth-century description.

▧ Colored marble floors in geometric patterns were common in Roman houses. The one below is from the *tablinum* of the House of the Faun in Pompeii. It is copied in the Getty Villa's entrance vestibule (right), where it is set into the white mosaic floor. A very similar floor has recently been excavated in a room near the atrium of the Villa dei Papiri.

■ The floor of the *tablinum* of the House of the Faun in Pompeii.

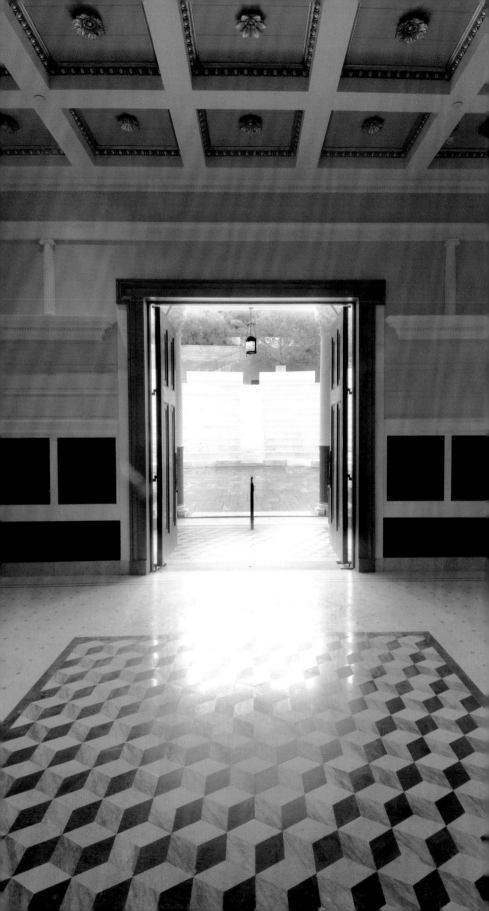

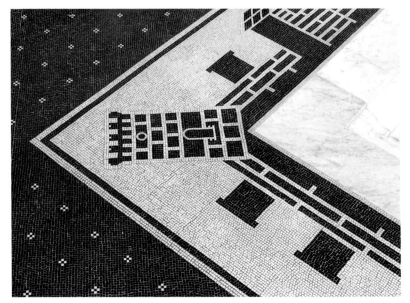

■ The eighteenth-century explorer of the Villa dei Papiri reported finding a mosaic floor depicting a cityscape surrounding the *impluvium* of the atrium. That floor no longer exists, but a similar floor has been installed around the Museum's *impluvium*.

The doors of the *cubicula* on both sides of the atrium in the Villa dei Papiri—the villa's original bedrooms—had been walled over by the time Vesuvius erupted in A.D. 79, and niches in these walls were used to display bronzes. One niche featured fourteen bronze civet heads that spouted water into a lead basin. These provided the prototype for those decorating the central fountain in the Museum's East Garden (see p. 85). The small rooms off the Atrium today house small galleries or serve as vestibules to larger display spaces.

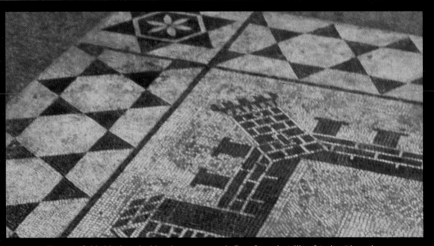

■ Part of this black-and-white cityscape mosaic floor from the Villa of Arrius Diomedes at Pompeii was copied in the Getty Villa.

The Inner Peristyle, decorated in the style that was in fashion in the second century B.C., when the main block of the Villa dei Papiri was constructed, is much smaller and more intimate than the Outer Peristyle. Plantings include laurel, viburnum, and myrtle, as well as rosemary hedges, lavender, acanthus, and ruscus. This pleasing green space is defined by thirty-six Ionic columns surrounding a garden, and a long, narrow central pool that emphasizes the Villa's west-east water axis. Replicas of bronze statues of women that were excavated in the Villa dei Papiri have been placed on curved marble offsets along the pool's sides. Although the originals after which these copies were made were found in the outer peristyle of the Herculaneum villa, the inner peristyle appears to have been their original setting, for they fit into its semicircular areas perfectly and seem to depict women who have come to draw water from a stream. The white marble fountains in the corners of the garden were re-created from an early drawing and from a description in Weber's excavation reports, and the four portrait busts near them copy pieces found in the colonnade. The two on the north side of the pool are fictive portraits of early Greek philosophers, possibly Herakleitos and Pythagoras (or Demokritos). The two on the south are heads abstracted from famous Greek statues of the fifth century B.C. The originals after which the Villa dei Papiri heads are copied were lost in antiquity, but they are known in numerous other versions and from ancient

Copies of two bronze busts are installed in opposite corners of the Museum's Inner Peristyle. The head of the young man is a copy of Polykleitos's *Doryphoros* ("Spear-bearer"), a statue famous already in antiquity. The other is an unidentified young woman, possibly an Amazon, in the style of Polykleitos.

literary sources. The male figure (to the east) is modeled on the *Doryphoros* (spear-bearer) of Polykleitos, and the female is possibly an Amazon, thought to be by the same sculptor. The Herculaneum *Doryphoros* is among the finest surviving examples of the type, and it bears the signature, not of Polykleitos, but rather of the copyist. The inscription on the base reads: "Apollonios the son of Archaios of Athens made [this]."

The terrazzo floors of the colonnade (called *opus signinum* by the Romans) are of a type common in Roman houses. Pebble-sized pieces of marble, granite, and brick were set in concrete, ground down to a smooth surface, and polished. Weber described marble and mosaic floors in the Villa dei Papiri, but it is possible that some of the floors that he called "mosaic" were in fact terrazzo. The different patterns of terrazzo throughout the Museum are both ancient and modern.

The color accents on the four-sided Ionic capitals (see p. 73) are modeled on the columns of a house in Pompeii appropriately called "The House of the Colored Capitals." The small plaster-relief floral coffers in the ceilings of the colonnade are based on coffers from a dismembered monument on the Street of the Tombs in Pompeii, and the five-spouted bronze hanging lamps decorated with the head of Medusa (see p. 73) copy another type found at Pompeii. The walls, in the First Pompeian Style, are colored plaster relief panels representing stonework and pilasters. They are based upon those in the large peristyle of the House of the Faun, one of the most elegant houses in Pompeii. The detail of the row of nonfunctional tiles and antefixes above the entablature is typically Graeco-Roman and permits the viewer to conceive of the lower floor as a distinct unit; the upper colonnade takes the form of engaged unfluted Corinthian half columns flanking windows with bronze mullions.

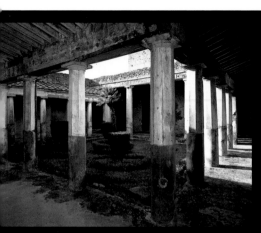

■ The garden of the House of the Silver Wedding in Pompeii (above) has a square peristyle similar to the one in the Getty Villa (opposite).

■ This ancient basin was the model for the fountains in the Inner Peristyle. From Charles Nicolas Cochin and Jerome Charles Bellicard, *Observations sur les antiquités de la ville d'Herculaneum* (Paris, 1754), pl. 11, p. 26.

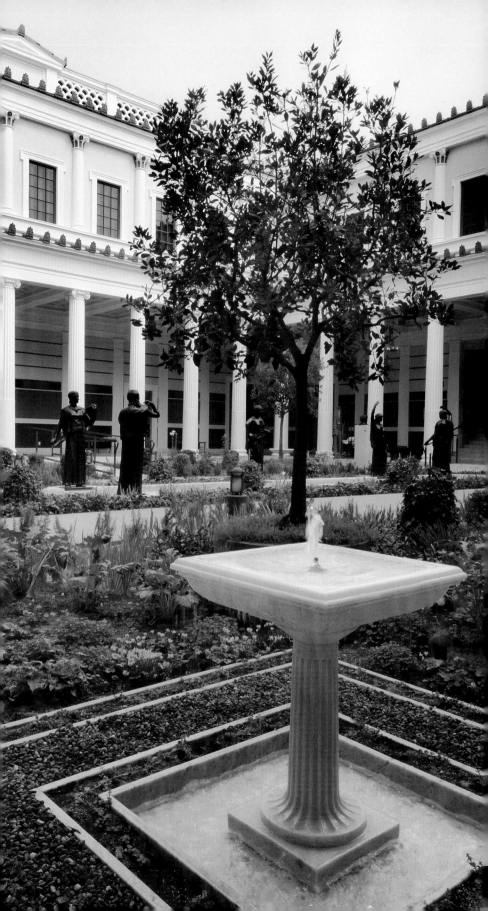

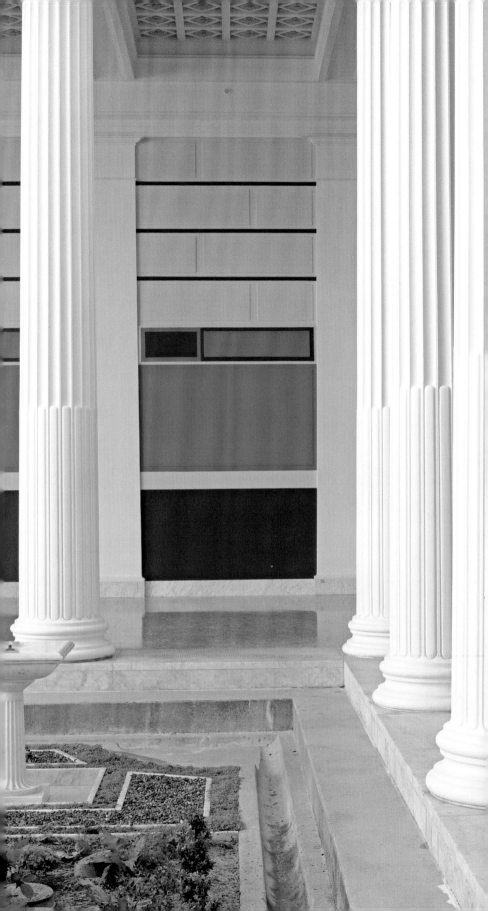

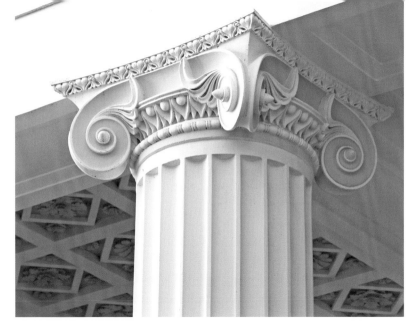

The graceful Ionic colonnade of the Inner Peristyle (left) is surrounded by walls decorated in the First Style of Roman painting. The four-sided Ionic capitals (above) replicate those found in the House of the Colored Capitals at Pompeii. The coffered ceiling comes from a dismembered monument on the Street of the Tombs in Pompeii. The five-spouted ceiling lamps (right), decorated with heads of satyrs surrounding a central Medusa, are replicas of ones found in Pompeii.

This wall (left) from the large peristyle of the House of the Faun at Pompeii was the model for the First Pompeian Style walls of the Getty Villa's Inner Peristyle. The plaster reliefs of the coffered ceiling are based on stonework from the Street of the Tombs at Pompeii (right).

In the northwest corner of the Inner Peristyle, a small vestibule (Gallery 107) leads to one of the most opulent spaces in the Villa, the so-called Basilica (Gallery 106). In the first century A.D., the Roman architectural historian Vitruvius used the word *basilica* to describe a very large room that would usually have been a public hall, but that was occasionally constructed as part of a private house. Such rooms may have been used as meeting halls or private shrines. Weber's plan of the Villa dei Papiri shows a room with an apse (a vaulted semicircular space) at one end and an anteroom with columns at the other. The Museum's Basilica is a plausible representation of how this space may have looked. Eight white marble columns divide the Basilica into a wide nave with two extremely narrow side aisles. This basic plan was adopted by early Christians for their churches. The unusual Corinthian capitals here, carved in four different colors of marble, are modeled after an example found in the garden of the House of the Deer in Herculaneum.

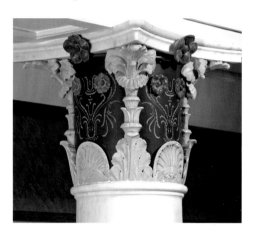

The bells, with their incised designs, are made of Belgian black marble; the shells and leaves are of yellow Siena; and the flowers are of a red marble from Monte Amiata. The abaci just below the horizontal lintels, at the very top, are of white marble from Carrara.

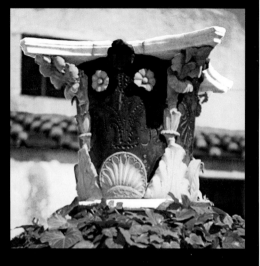

■ The elaborate multicolored Corinthian marble capitals of the Basilica (above and far right) were copied from a single capital found in the House of the Deer in Herculaneum (right). Since this photograph was taken in 1949, much of the ornament on the capital has been removed by vandals, and the remains are overgrown with ivy. The Basilica's floor of ancient marbles reproduces one found in the Villa dei Papiri.

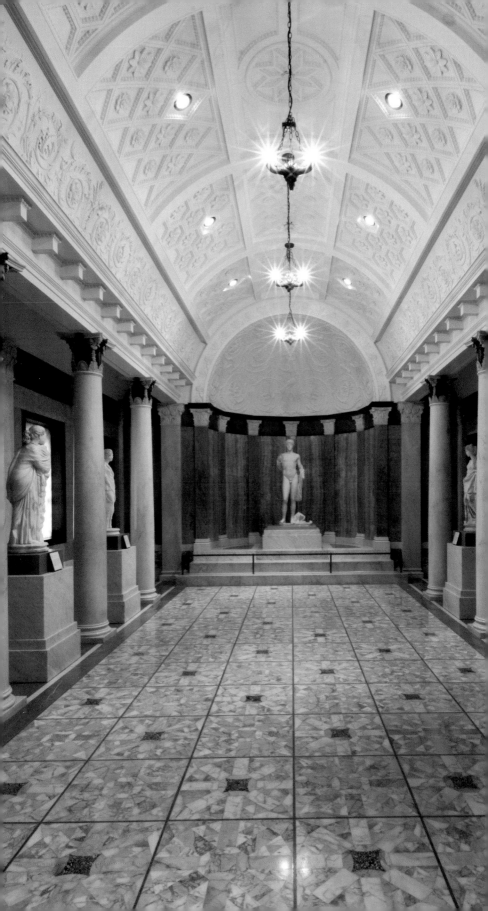

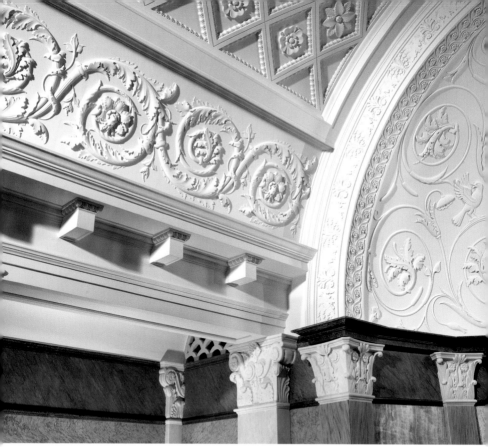

The elaborate plaster acanthus-scroll decoration of the barrel-vaulted ceiling of the Basilica (above) was inspired by a wall in the Forum Baths at Pompeii (below). The acanthus motif of the semidome is from a niche in the House of Menander at Pompeii.

Imitating ancient practice, the windows of the Basilica are covered with very thin sheets of alabaster that permit a soft light to shine through (opposite).

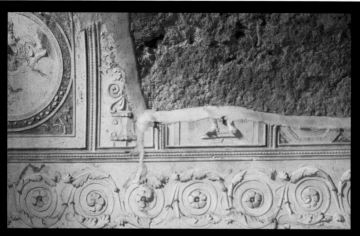

The relief decoration of this ceiling in the Forum Baths at Pompeii was produced in plaster on top of concrete.

The sidewalls are divided into bays by pilasters and capitals of white marble. The low wainscotting is of Italian, rather than Greek, veined gray *fior di pesco* marble. It comes from a recently exhausted quarry in Tuscany much favored by the Medici in the sixteenth and seventeenth centuries. Above is a band of white Carrara marble. *Cipollino* (a kind of veined marble resembling onions, whence its modern Italian name) surrounds recesses framed in black slate. These recesses are covered with slabs of honey-colored onyx from the Adriatic. Alabaster windowpanes behind two of the panels admit soft light into the room. The intricate stucco work on the barrel-vaulted ceiling combines details from several Pompeian buildings: the coffered panels are based on those found in the House of the Cryptoporticus, while the acanthus scrolls along the sides were inspired by the ceiling in the Forum Baths. The acanthus motifs in the semidome over the apse were copied from a niche in the House of Menander.

The Basilica floor is a replica of one known to have existed in the Villa dei Papiri; it uses ancient marbles to re-create the intricate tiles of *giallo antico,* yellow marble from Numidia in North Africa; *pavonazzetto,* a white marble from Turkey with dark purple veins that recalls a peacock's markings; and green Egyptian granite divided by thin strips of *rosso antico.*

ROOM OF COLORED MARBLES

Directly west of the Basilica is the Room of Colored Marbles (Gallery 105), another luxurious space. By the first century A.D., wealthy Romans were using an array of colored marbles to cover floors and walls and to line fountains and pools. Usually imported from distant lands, different stones not only served as decoration, they also demonstrated the power of Rome and the extent of its conquests and thus manifested the wealth and power of the owners of elite homes. Marble was used either in large slabs or in small pieces that were combined to create intricate geometric patterns of different colors and shapes. To evoke the Romans' interest in marble as a decorative material with a wide range of colors and uses, the Museum's designers employed it extensively throughout the building, even though information about its specific uses in the Villa dei Papiri remains scarce. Although the decoration of this room is not as intricate as that of others, it does employ the greatest variety of marble.

The room reproduces a floor still in place in the House of the Relief of Telephos in Herculaneum and is cut entirely from salvaged ancient fragments. Square tiles of geometric patterns in *giallo antico, pavonazzetto,* green porphyry, and *rosso antico* are bordered by *cipollino*. The wall paneling combines marbles and motifs from a number of ancient sources. The lower register consists of a band of *cipollino* below *giallo antico* squares surrounding disks of red Egyptian porphyry alternating with panels of Euboian *fior di pesco* bordered in green porphyry. This design was taken from painted decoration in the House of the Vettii at Pompeii. The main zone, above a second band of *cipollino,* has alternating large panels of *verde antico* and *fior di pesco* framed in white Carrara and surrounded by Marathon gray. Above, a wide band of *cipollino* is followed by a projecting cornice of *rosso antico,* a high attic of striped gray Pentelic, another cornice of *rosso antico,* a band of especially rich *giallo antico,* and finally a more massive cornice of *rosso antico.* The two pink Aberdeen granite columns in the room are from Lansdowne House in London, an eighteenth-century building designed by the Neoclassical architect Robert Adam. This granite is the only stone in the room from a source not known in ancient times.

■ In the Room of Colored Marbles—so called because fourteen different varieties are used here—the costly decoration copies both the patterns and the marbles of known ancient houses. The floor is made entirely of ancient marble fragments, while the walls combine ancient pieces and pieces recently quarried from sites known to have been exploited in antiquity.

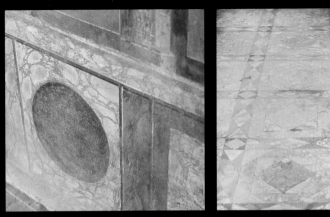

■ The marble veneer on the walls is derived from the House of the Vettii in Pompeii.

■ The floor is a copy of one in the House of the Relief of Telephos in Herculaneum.

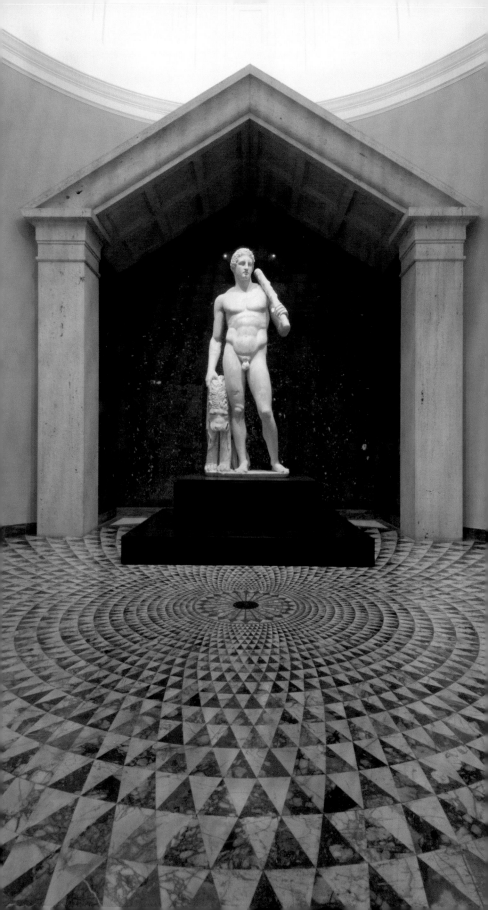

In the middle of the northern portico of the Inner Peristyle, accessible through a small vestibule (Gallery 108a), is a circular domed room, an adaptation of an underground sanctuary found at Monte del'Incastro, halfway between Rome and Tivoli. This area featured many sanctuaries dedicated to the hero/god Herakles, the son of the supreme god Zeus (the Roman Jupiter) and the mortal Alkmene.

The room's circular floor, an exact replica of the belvedere floor that marked the rediscovery of the Villa dei Papiri in the eighteenth century, is an excellent example of both the complex geometric patterns favored by the Romans and the variety of different marbles that could be incorporated into one pavement. It consists of twenty-two concentric circles, each composed of triangles of *giallo antico* alternating with triangles of black *africano,* or Lucullan, marble. The slab in the middle contains arrows of *rosso antico* on a background of *giallo antico* surrounding a center of green Greek porphyry. Thus the Museum's floor, with some four thousand pieces, uses the same kinds of antique marbles as the original floor from the Villa dei Papiri.

The cult niche of the ancient sanctuary at Monte dell'Incastro had been ripped out, presumably by early Christians, so it was necessary to design a niche for the Museum's Temple. It consists of panels of *verde antico* bordered by dark red porphyry in a pedimental frame of travertine. The other walls have been plastered, with delicate floral mosaics in the half domes of the side niches modeled on those in the original shrine, and the ceiling dome has coffers based on those of the Pantheon in Rome.

A room like this would never have existed in a private Roman home. It was especially designed for the Museum to house the Lansdowne Herakles,

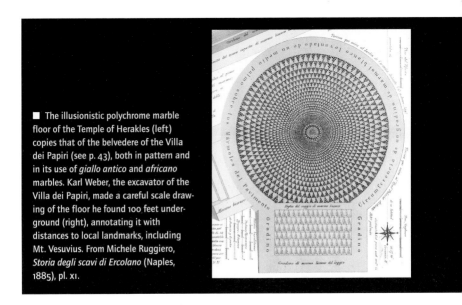

■ The illusionistic polychrome marble floor of the Temple of Herakles (left) copies that of the belvedere of the Villa dei Papiri (see p. 43), both in pattern and in its use of *giallo antico* and *africano* marbles. Karl Weber, the excavator of the Villa dei Papiri, made a careful scale drawing of the floor he found 100 feet underground (right), annotating it with distances to local landmarks, including Mt. Vesuvius. From Michele Ruggiero, *Storia degli scavi di Ercolano* (Naples, 1885), pl. XI.

the statue considered by Mr. Getty to have been the most important work of art in his collection. This life-size statue of the young Herakles was found near Hadrian's Villa at Tivoli, the same region in which the sanctuary was discovered. It was purchased by Mr. Getty in 1951 from the Marquess of Lansdowne, whose ancestors acquired it in 1792. Other statues exhibited in this room also come from historic collections.

EAST STAIR

A monumental staircase installed in 2005 on the east side of the Inner Peristyle, on axis with the Museum Entrance, deviates from ancient Roman domestic architecture. The upper floors of Roman dwellings were reached by narrow, almost hidden stairs. But this modern stairway, lined with yellow *amarillo Triana* marble imported from Spain and suspended, on the upper level, on bronze runners, is a concession to the needs of modern visitors (as is the elevator in the marble-lined Triclinium to the south).

■ The East Stair is the only part of the Getty Villa not based on Roman architecture and design: The Romans had no grand staircases. Clad in yellow marble from Spain, the East Stair provides easy circulation between the two floors of the Museum without obstructing the view of the axis from the Atrium through the Inner Peristyle to the East Garden.

EAST GARDEN

Underneath the East Stair, two bronze doors lead to the East Garden, one of the most tranquil spaces in the Villa. In the center, surrounded by sycamore and laurel trees, is a circular basin decorated with bronze civet-head spouts copied from those discovered in the atrium of the Villa dei Papiri. The garden's second fountain is a spectacular mosaic-and-shell niche fountain, the exact copy of one in the House of the Great Fountain at Pompeii. The projecting merlons at the top of the walls, reminiscent of fortifications, are a typical feature of Roman boundary walls. The false stonework on the outside of the Museum building is a common feature of Roman facades, both public and private. The small East Porch, with its two columns, was inspired by the entrance of the great Villa San Marco at Stabiae. The plantings include mulberry trees, laurels, boxwood hedges, ivy, ruscus, fern, acanthus, and viburnum.

■ The eponymous fountain in the garden of the House of the Great Fountain at Pompeii.

■ Detail of one of the theater masks depicting Herakles from the fountain in the House of the Great Fountain at Pompeii.

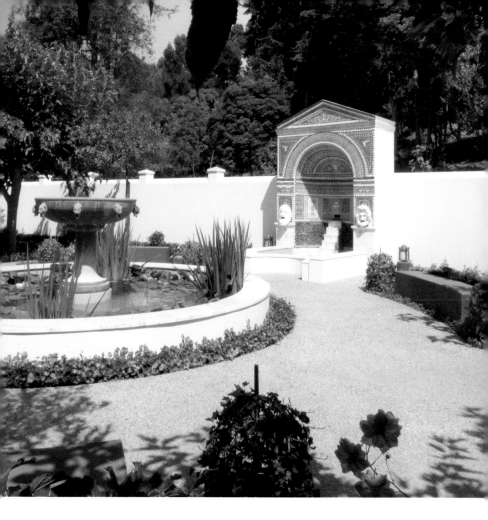

In the East Garden water cascades through the civet heads of a circular fountain (above). The heads are copies of some fourteen life-size bronze heads that spouted water into a basin in a niche of the atrium of the Villa dei Papiri. The mosaic fountain in the background, adorned with marble theater masks, is a copy of that in the garden of the House of the Great Fountain at Pompeii.

The small round ears and bulging eyes of an animal head from the fountain belong to a small carnivore, the civet, found in North Africa and Europe. Civets can be domesticated, and it is likely that the owner of the Villa dei Papiri was familiar with these animals.

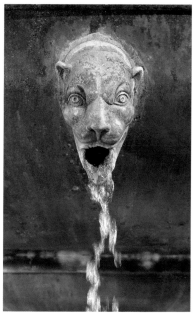

TRICLINIUM

One of the most important rooms of a Roman house was the *triclinium*, the main dining room, where the host would entertain guests. As in the Villa dei Papiri, the sumptuously decorated Triclinium of the Getty Villa is located on the side of the Inner Peristyle and provides access to the large Outer Peristyle, which lies on the other side of two massive bronze doors. The Triclinium is separated from the Inner Peristyle by two richly carved Corinthian columns of white marble on high pedestals. Marble columns were an integral feature of the Roman architectural vocabulary, but until the second century A.D. they were used almost exclusively for public buildings and temples rather than private houses. The columns between the Triclinium and the Inner Peristyle in the Malibu Villa are meant to complement the marble used on the floor and walls, but they are actually more elaborate than any such supports that would have been found in a private house before the second century.

The floor and walls of the Triclinium are inlaid with colored marbles in designs replicated from various ancient buildings. This type of decoration came into vogue in the late first century B.C. and was particularly popular in Herculaneum. Eighteenth-century excavation reports repeatedly refer to the quantities of colored marbles found at and removed from the site. The complex geometrical pattern of the Triclinium floor copies that found in the House of the Deer at Herculaneum. It incorporates four types of marble: wine-colored porphyry from Egypt, dark green porphyry from Sparta, white *pavonazzetto* from Phrygia in present-day Turkey, and yellowish pink Numidian (*giallo antico*) from Tunisia. As these marbles are no longer quarried, the floor is made of recut salvage pieces obtained from the Ditta Medici firm in Rome.

■ The Triclinium (right) is one of the most lavish spaces in the Getty Villa. Its marble floor and walls, copied, respectively, from the House of the Deer (above left) and the House of the Relief of Telephos (above right) at Herculaneum, illustrate the decoration of the most lavish ancient buildings. Eleven different types of marbles are used in this room. The ceiling is based on one in the House of the Fruit Orchard at Pompeii.

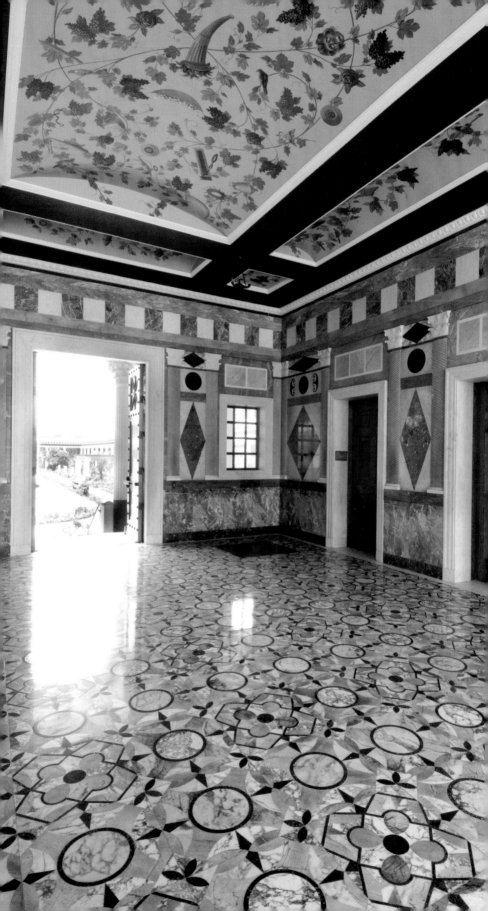

The walls combine ancient marbles with pieces taken from ancient quarries still in use. A dado (base course) of red, violet, and white *fior di pesco* from the Greek island of Euboia rests atop a baseboard of *verde antico* (see p. 87) from Thessaly in northern Greece and is topped by a strip of gray marble from Marathon. This unit is a base for the main zone: paired slightly convex Corinthian pilasters of gray-green Italian *cipollino* with diagonal fluting have bases and capitals of white marble with a necking of ancient *rosso antico* from Greece.

■ Details of the floor (above) and the wall (opposite) of the Getty Museum's Triclinium.

These pilasters are modeled on those decorating a luxurious room in the House of the Relief of Telephos in Herculaneum. The panels flanked by the paired pilasters are divided into three zones: the tall lower zones have large diamonds of *verde antico* surrounded by *giallo antico;* a band of Marathon gray is topped by another panel of yellow Numidian marble inlaid with a disk of Egyptian red porphyry either alone or flanked by decorative *peltai* (a type of shield) in green porphyry. This is topped by a continuation of the *rosso antico* of the necking for the capitals and a diamond of green porphyry surrounded by *pavonazzetto*. Above the white marble door frames and windows are squares of yellow Numidian marble set off by strips of white with a background of pinkish ancient *portasanta* from the Greek island of Chios off the coast of Turkey. The frieze on top consists of a band of Marathon gray, one of Numidian yellow, a row of squares of white alternating with *fior di pesco*, a wide band of Italian *cipollino*, and a thin strip of *rosso antico* at the top (see p. 87).

The ceiling, set off from the wall by a bold egg-and-dart molding, has recessed, arched panels in a design similar to those in several houses in Herculaneum, and its illusionistic vine motif incorporates cupids, birds, flowers, fruit, musical instruments, and other images taken from the House of the Fruit Orchard in Pompeii. The floral elements are intended to link the Inner and the Outer Peristyle Gardens.

In the ancient villa a statue of Athena was placed between the two columns separating the square peristyle from the *triclinium*. A number of busts were found in the room. On the east side of the Malibu Triclinium an elevator and a marble-lined stair provide alternate routes to the upper level.

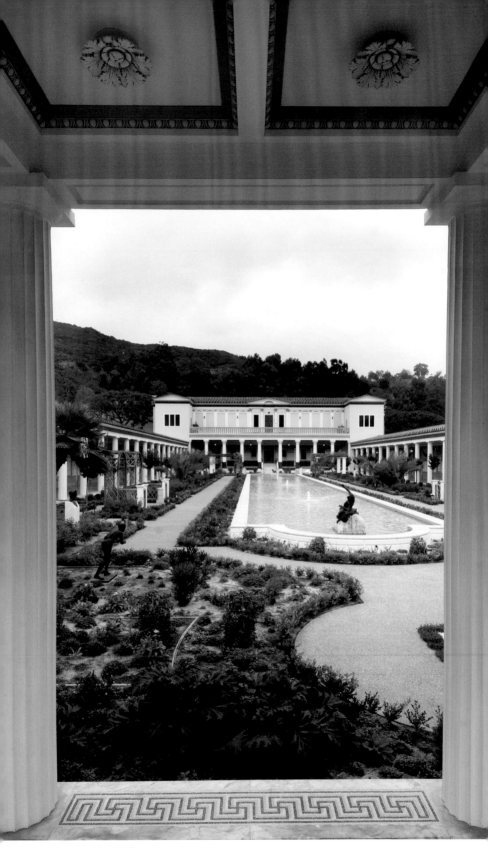

Two bronze doors, as well as flanking windows, open from the Triclinium onto the Outer Peristyle. One of the most impressive sights at the Villa, larger than the fora of many ancient cities, the garden is framed on each side by porticoes. To emphasize the Museum building, the north colonnade is larger, creating a "Rhodian" peristyle. Here eight grand Corinthian columns flanked by two pilasters take the place of the ten smaller columns of the original Villa dei Papiri. Except for the unfluted lower portions of their shafts, these columns and their capitals are copied from those of the Basilica at Pompeii. Smaller Doric columns adorn the three other sides of the garden.

The focal point of the Outer Peristyle is the large pool framed by symmetrical landscaping. The original pool in the Villa dei Papiri was approximately six feet deep, being designed to hold fish, but a pool so deep in Malibu would have intruded into the parking garage below and would also have necessitated a lifeguard. The large, semicircular benches in front of the Museum portico, based on examples in public locations in Pompeii, have intricately patterned floors of slate and limestone. The garden features trimmed hedges of box, mounded ivy, oleander, hellebore, ruscus, lavender, thyme, viburnum, violets, bellflowers, irises, and narcissus. Two square arbors are covered with grapevines, and trellis bases are planted with acanthus, the plant whose leaves inspired endless decorative motifs in antiquity. Trimmed laurel, fan palm, and pomegranate trees further enhance the peaceful atmosphere of this garden.

In and around the pool and throughout the garden are copies of bronze statues and busts, which were cast in Naples after those found in the Villa

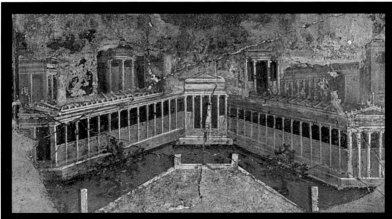

■ The Getty Villa's Outer Peristyle (left) matches the size of the one in the Villa dei Papiri. The interior garden, without the peristyle, measured 308 x 105 feet; the pool was 220 feet long. The peristyle resembles one depicted in a Roman wall painting of a seaside villa (above). Naples, Museo Archeologico Nazionale, inv. 9406.

■ Modern replicas of the bronze statuary from the Villa dei Papiri, such as the seated messenger god Hermes (Roman Mercury, Etruscan Turms), are placed throughout the Getty Villa gardens.

■ Another statue replica, of an aging drunken satyr, is placed on a rock at one end of the large pool, near the spot it occupied in the Villa dei Papiri.

dei Papiri. They have been placed approximately where Weber found them. Two graceful deer flank the steps leading down into the garden from the Museum colonnade. Busts and statues of gods, heroes, rulers, poets, and athletes, sculpted in a variety of styles, are symmetrically placed throughout the garden. At the north end of the pool a beardless young satyr sleeps on a rock, while an older drunken satyr is found at the other end. At the far end of the garden, on the central axis, is a fine seated figure of the messenger god Hermes. He wears winged sandals, the straps of which are fastened on the soles of his feet by roses, for he had no need to tread on the ground.

The walls of the north, east, and west porticoes are decorated with illusionistic paintings of the Second Pompeian Style, which was fashionable in the first century B.C., and the colors match actual ancient paint specimens. Behind the central sections of the Museum's Corinthian colonnade (to the north) are painted unfluted composite columns with yellow bases, bands, and bosses. These columns are surmounted by yellow Corinthian capitals supporting a white cornice. This composition creates the illusion of a double colonnade. Seemingly behind the painted columns is a wall of purple, white, and green faux-ashlar blocks that is punctuated by yellow pedimented window frames. At the east and west ends the paintings are still more complex, with monolithic columns supporting elaborate pediments. Garlands adorn the lower part of the wall on either side of doorways,

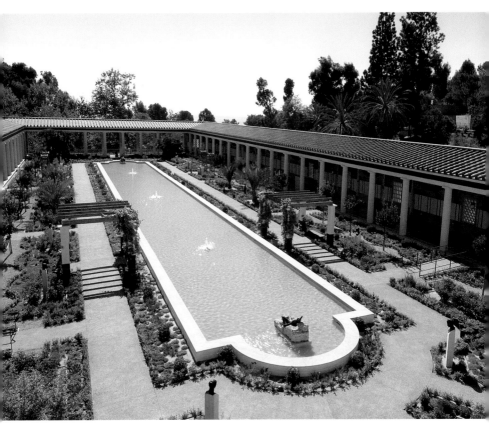

■ The gardens of the Getty Villa are as authentically Roman as possible. They use trees, shrubs, and flowers enjoyed by the ancient Romans, in planting patterns known from wall frescoes and from the gardens of Pompeii and Herculaneum. Among the plants are laurel, pomegranate, boxwood hedges, ivy mounds, myrtle, oleander, roses, acanthus, crocus, and narcissus.

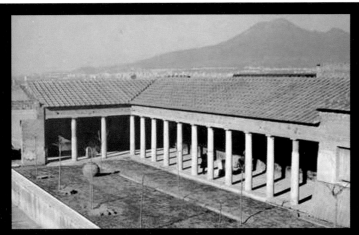

■ As in antiquity, Mt. Vesuvius looms behind the so-called Villa San Marco in Stabiae. This villa, which was buried in the volcanic eruption of A.D. 79, had a large peristyle garden with a central pool similar to those in the Villa dei Papiri.

The walls of the portico at the north end of the Outer Peristyle, in front of the Villa building, are decorated with a variety of frescos copied from or based on Roman wall paintings. The windows are surrounded by painted pediments and an illusionistic double door, half ajar, is painted between them.

behind which open deep colonnaded courtyards and gardens. The extreme ends of the north colonnade feature paintings of circular temples within additional colonnaded courtyards and shields hanging above broken pediments. These repeat a motif known in a number of Pompeian examples, such as the House of the Labyrinth and the Villa of P. Fannius Synistor at Boscoreale.

In the east and west corners are animal still lifes that reproduce rare fragments of ancient paintings from the Villa dei Papiri: four live ducks hang above two small trussed deer. Such motifs were popular in Roman murals and were frequently employed to decorate dining areas, for in Roman cuisine, as is true today, both duck and venison were considered delicacies. On the ledge above are frescoed baskets and glass

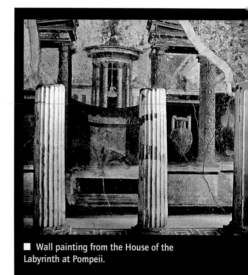

Wall painting from the House of the Labyrinth at Pompeii.

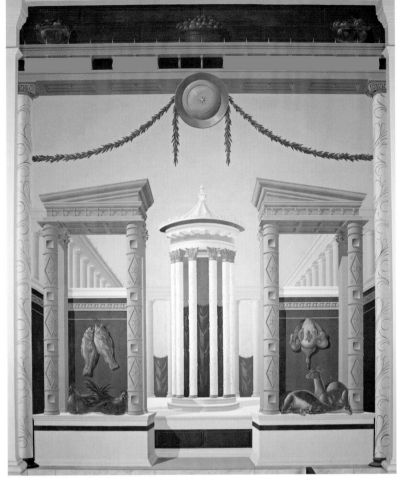

■ The small round structure (*tholos*) depicted on the wall of the portico at the top of the Outer Peristyle (above) is based on a similar wall painting from the House of the Labyrinth at Pompeii (below, far left). The still life on the right replicates one of the few extant wall paintings from the Villa dei Papiri (below, middle).

■ A wall painting from the Villa dei Papiri (above, left) shows two small, trussed deer lying beneath four live ducks hanging on a wall. Naples, Museo Archeologico Nazionale, inv. 8759. The glass-bowl mural (above, right) from the Villa of Poppaea at Oplontis was the inspiration for the fruit bowls at the top of the Getty mural (top of page).

bowls of fruit copied from the luxurious villa at Oplontis, near Pompeii, that belonged to the family of Nero's wife, Poppaea. The extremely illusionistic painted architectural framework that surrounds the side doorways was suggested by a detail of the House of the Griffins in Rome. The coffered ceiling of the main porch is patterned after the traces of a wooden ceiling that left its form in the hardened ash that buried the Villa of P. Fannius Synistor. The view of the gardens looking south toward the sea is especially attractive from this porch and from the balcony above. Another fine view of the sea can be had from the colonnade at the south end of the garden, which has been left open, unlike that of the Villa dei Papiri.

The walls of the side porticoes have been painted with garlands of flowers and fruit copied from the Villa of P. Fannius Synistor, as well as with illusionistic frescoes depicting elaborate columns in front of plain or carved marble panels and niches. Weber's excavation reports mention numerous small paintings that were cut out of the walls and brought to the Royal Museum at Portici, but most seem to have been in poor condition. Thus the majority of the wall paintings in Malibu are based on prototypes from other ancient houses, with the exception of the still lifes in the corners of the Museum portico mentioned above. The frescoes on the long sidewalls are divided into bays by painted columns aligned with the real ones. The division is echoed in the rose-colored terrazzo floor panels, which are separated by strips of mosaic in a meander pattern. Alternate bays of the sidewalls have windows filled with massive ornamental cement grilles, with three different patterns. At certain times of the day the grilles cast interesting shadows on the floor. The windows themselves are topped with painted decorative pediments and are flanked by pairs of metal urns against a receding

■ The Doric columns of the long colonnade in the Outer Peristyle (far right) are modeled on a similar colonnade from a house in Stabiae.

■ This mosaic floor pattern from a house in Pompeii was copied in the Getty Villa's Outer Peristyle.

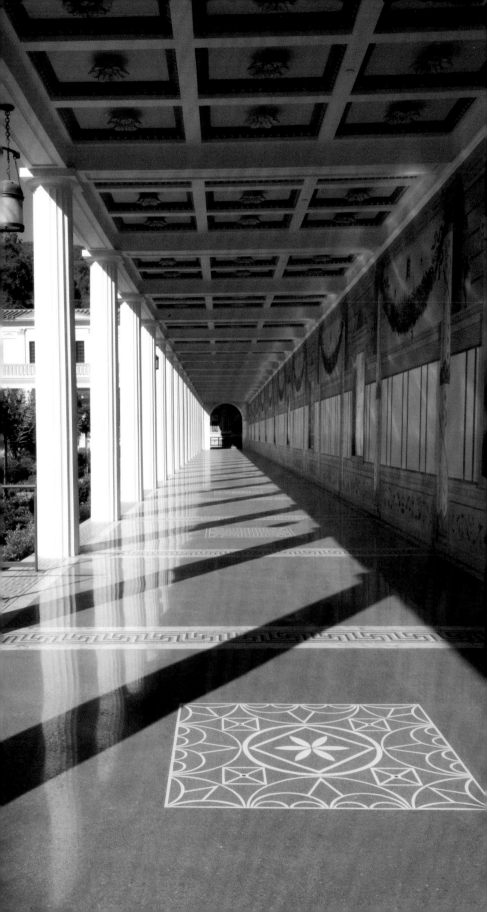

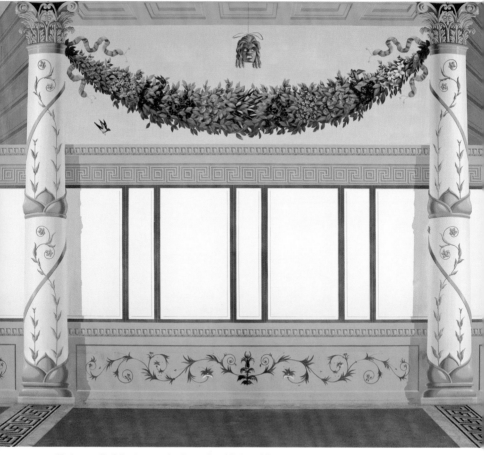

■ On a wall of the Outer Peristyle a painted fruit-and-flower swag is suspended between two illusionistic columns with Corinthian capitals. On the left and right of the two columns the painting creates the illusion of walls of green ashlar blocks separated by red cement.

■ Wall painting of a fruit-and-flower swag from the Villa of the Mysteries at Pompeii.

■ A detail of one of the fruit-and-flower swags on the walls of the Outer Peristyle shows a small bird about to sample one of the blue grapes while another bird eyes the pinecones and figs.

background of stonework in green. The painted columns defining the bays are of four types and appear in pairs. In the blank wall bays, garlands against the blue sky are tied to matching columns. The garlands alternate, some with fruit, others with flowers (each in two versions). A theatrical mask hangs above each. Birds, lizards, and insects have been inserted here and there to add liveliness to the compositions. Each bay has its own perspective, which is seen most convincingly from a vantage point between the real Doric peristyle columns. The typically Roman scheme of alternation, permutation, and combination is such that no two bays are exactly the same.

The Herb Garden is located below the Museum Path, immediately west of the Outer Peristyle, and running its entire length. Accessible from either the north or south end of the Outer Peristyle, or from the Museum Entrance, this re-creation of a Roman kitchen garden contains arranged beds of some fifty different kinds of herbs that were used in Roman times. Herb gardens were an important part of Roman houses; their plants were used for culinary, medicinal, aromatic, religious, and decorative purposes. At the Villa dei Papiri this area seems initially to have been an exercise track, which was later converted to a garden area with walkways around a pool and a fountain. Although we do not know precisely which plants were grown at the villa, ancient texts by such diverse authors as Virgil, Cato the Elder, Theophrastos, Galen, Dioskourides, Apicius, and Pliny the Elder mention the cultivation of numerous herbs in Roman antiquity. As noted earlier, carbonized remains, root cavities, and pollen from other gardens scientifically excavated at Pompeii and Herculaneum, as well as the depictions of gardens in ancient wall paintings, provide further evidence for the contents and arrangement of Roman domestic gardens.

The Getty Herb Garden contains mint, dill, coriander, oregano, marjoram, chamomile, parsley, and several kinds of thyme. Fennel, peas, and other vegetables are planted among them. Fruit trees—apple, peach, pear, fig, and citrus—and grapevines abound. A typically Mediterranean olive grove stands on the terraces above the garden, at the foot of the Museum Path.

■ A Silenos riding a bulging wineskin (above)—a copy of a statuette found in the *impluvium* of the Villa dei Papiri—forms a water spout for a small basin in the Herb Garden. As in Mediterranean gardens, both in Roman times and today, the Herb Garden has terraces planted with olive trees (right). Other trees in the garden are date palm, pomegranate, plum, apricot, citron, quince, fig, and apple. Shrubs and herbs include lavender, rosemary, thyme, basil, oregano, sage, chamomile, and spearmint. Seasonal color accents are provided by iris, crocus, leek, chive, sweet violet, poppy, and buttercup.

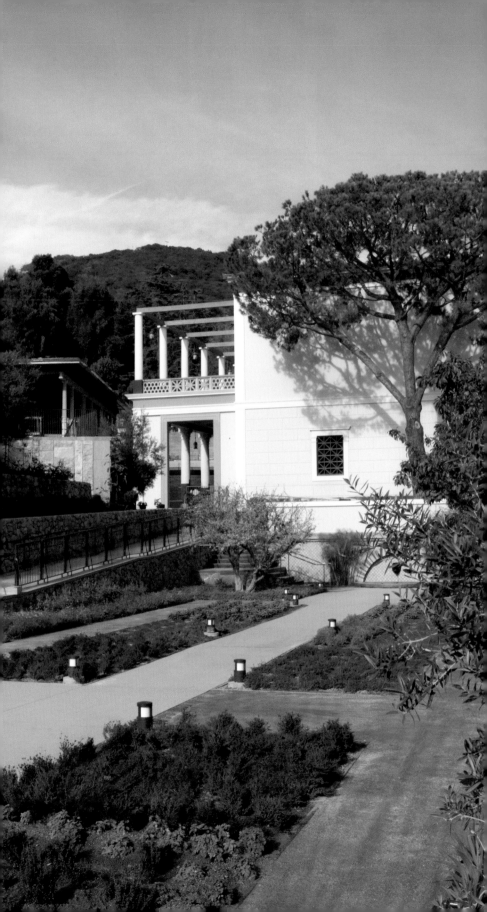

Adjacent to the Fleischman Theater are two features designed to make a visit to the Villa enjoyable and memorable: the Cafe and the Museum Store. The latter offers an array of publications relating to the antiquities collections and the building housing them, as well as objects suitable as gifts or souvenirs of a visit to the Villa. The Cafe serves a variety of light meals and snacks and beverages. Visible from the Cafe and Museum Store are two other additions to the Villa site designed to enrich the Museum programs: education facilities for schoolchildren surrounding what is called the Education Court, and, partially built into the hill below the Ranch House, the Auditorium designed for lectures and films complementing the Getty's activities.

■ Next to the top rows of the Outdoor Theater, the Cafe offers indoor and outdoor seating (left). At ground level under the cafe is the Museum Store (above). The different textures of this wall are meant to imitate the strata of the volcanic deposits that entombed the Villa dei Papiri after the eruption of Vesuvius in A.D. 79.

All the improvements to the original Villa site are specifically related to the Museum and its activities for the public. Because the permanent collection on display is centered on antiquities, the various Getty programs have taken the opportunity to create new activities that focus specifically on antiquity. In the part of the site called the North Campus—an area restricted to staff and visiting scholars and not open to the public—the Getty Research Institute and the Getty Conservation Institute now conduct a variety of programs devoted to classical antiquity.

In the Spanish-style Ranch House—Mr. Getty's home in the canyon, which can be seen from several points in and around the Museum—are offices for the curators of the antiquities collection, as well as the conservators of that collection, and participants in the Villa Scholars Program. Also located in the Ranch House is a small extension of the Getty Research Institute's much larger library at the Getty Center. Next to the Ranch House are laboratories for the conservation of the antiquities collection and an Office Building for Getty staff as well as Conservation Training Laboratories for the innovative program called the UCLA/Getty Masters Program on the Conservation of Ethnographic and Archaeological Materials. All of these buildings surround what is offically called the Conservation Court, but which is known by most Getty employees as the Monkey Court, so named after a fountain with three cast monkeys that has been located there since Mr. Getty's days.

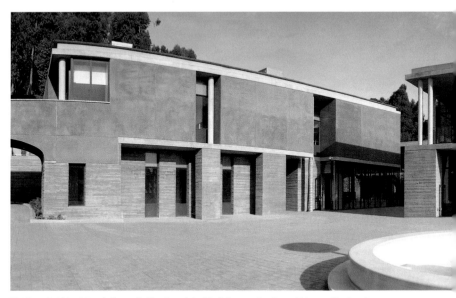

▨ The refurbished Ranch House (left)—the original building on the site, which was Mr. Getty's home—now houses offices for staff and visiting scholars. Adjacent to the Ranch House are the Conservation Training Laboratories for the UCLA/Getty Master's Program on the Conservation of Ethnographic and Archaeological Materials (above).

The Collections

HE OUTDOOR
peristyles and gardens of the Getty Villa are adorned with high-quality
replicas of ancient architecture, statues, and wall paintings from the Villa dei
Papiri and other ancient sites, but the J. Paul Getty Museum's indoor galleries
present only original works of art. The artifacts on display were produced by
ancient Greek, Etruscan, and Roman craftsmen. The oldest date back to as
early as 6500 B.C., but most were made between 700 B.C. and A.D. 300.

Unlike most museums exhibiting ancient art, whose collections are
presented strictly chronologically or by medium, the galleries at the Villa are
organized thematically, in order to highlight the original contexts and mean-
ings of the objects and the diverse roles they played in the societies that
produced them. Stylistic and historical developments are addressed explicitly
in the TimeScape Room (113), but all other galleries focus on specific aspects
of ancient culture (see plan on p. 128). For this reason, there is no preferred
path through the Museum. Rather, visitors are encouraged to explore the
galleries in any order of their choosing.

On the ground floor of the Villa, four small galleries that open onto
the Atrium (Galleries 101A–D) occupy what would have been bedrooms
in antiquity. They focus on specific materials: terra-
cotta and marble, silver, glass, and bronze. To the
right, a vestibule leads to the Theater & Spectacle
Gallery (114). This space, the closest to the outdoor

◼ Among the portraits
in the Men's Gallery is
this bust of the Roman
emperor Caligula.
J. Paul Getty Museum
72.AA.155.

Barbara and Lawrence Fleischman Theater, features ancient artifacts that depict scenes related to ancient drama.

On the opposite side of the Atrium, Gallery 104 introduces the gods and goddesses of the ancient world. Although these divinities had different names among the Greeks, Etruscans, and Romans, they can readily be recognized across the three cultures by their common attributes.

The lavish decorations of the Basilica (106) and Room of Colored Marbles (105) were discussed in detail above (pp. 74–79). These galleries house statues of divinities and luxurious silver vessels, respectively. Artifacts depicting some of the monsters and minor deities imagined by ancient peoples are presented in Gallery 107, while the galleries (108A–109) leading off from the Temple of Herakles (see pp. 81–82) are devoted to the heroes of classical mythology and their extraordinary deeds. Gallery 110 focuses on the most influential stories that have come down to us from the ancient world: those associated with the Trojan War. The display here, as elsewhere in the Museum, brings together marble and bronze sculpture, painting, mosaic, engraved gemstones, and even a papyrus fragment.

The Family Forum (111), meanwhile, provides a fun interactive space to explore the making and decoration of ancient Greek pottery.

Upstairs, to the left of the main staircase, Gallery 217 contains the oldest objects in the collection: Neolithic clay figurines, marble bowls and statuettes from the Cycladic islands, and gemstones and ceramics from the Minoan and Mycenaean cultures.

The upper elevator vestibule (213), meanwhile, presents griffins, fierce mythical beasts that were part eagle, part lion.

The upper peristyle galleries (201B and C) display images of animals and funerary sculpture, while Galleries 209, 210, and 211 are devoted to men in antiquity, the Victorious Youth, and athletes and competition. Gallery 207, on the opposite side of the Atrium, features women and children. On the west side of the Villa, between the galleries devoted to women and children and to men, Gallery 208 holds ancient religious offerings.

Not to be missed is Gallery 212, a small treasury that contains a wealth of ancient gems, coins, and jewelry. And Gallery 206, holding the arts of Graeco-Roman Egypt, has beautiful Fayum portraits and the Museum's mummy.

Finally, Galleries 202–205 provide space for changing exhibitions, as does the small Gallery 214. It is located on the other side of the main staircase, near the beautiful, sun-bathed, wood-paneled reading room (215) and a room equipped with GettyGuide computer terminals (216), where visitors can explore various aspects of the collections.

THEATER AND SPECTACLE

Theater, as we now know it, has evolved from the religious practices of the ancient Athenians. Drama grew out of the ritual worship of Dionysos (Fufluns to the Etruscans, Bacchus to the Romans), the Greek god of wine, vegetation, and theater. Music and singing were other important elements in the seasonal festivals honoring this god. Over time, choral performances developed into plays that combined speaking roles with songs. By the fifth century B.C., playwrights presented competing productions at festivals. The standard program consisted of three tragedies followed by a bawdy play in which actors portrayed lusty satyrs. Comedies were performed at other festivals. Although the plays, which featured masked actors, were initially performed only once, before an audience of thousands, some were later revived in cities throughout the Mediterranean. These revivals significantly influenced the development of Roman theater. This gallery features a wide range of objects depicting actors, such as the Roman incense burner to the right, and Dionysos and his followers.

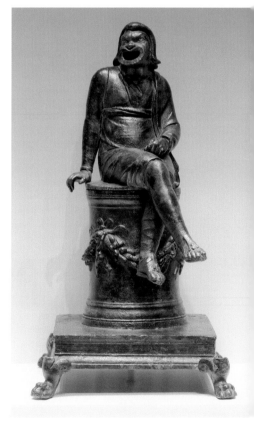

GODS AND GODDESSES

In antiquity, life revolved around religion and the worship of gods and goddesses, who inspired some of the greatest works of art. The Greeks, Etruscans, and Romans believed that the gods looked and behaved like humans, although they were distinguished by their immortality, beauty, and great powers. The gods were a family, with Zeus (Etruscan Tin/Tinia, Roman Jupiter, opposite upper right) the father. They had likes and dislikes, felt anger and happiness, enjoyed successes and suffered losses. Although they might be associated with specific sites, for example Athena at Athens, no city could claim a deity exclusively. Individual deities had particular character traits and oversaw particular aspects of life. Thus Aphrodite (Etruscan Turan, Roman Venus, opposite upper left) embodied sexuality, while Demeter (Etruscan Vei, Roman Ceres) revealed through Triptolemos, far right, the secret of agriculture to mankind. Throughout the ancient world, many days were set aside for religious festivals and activities, and gifts, often in the form of statues, such as Minerva (Greek Athena, Etruscan Menrva—right), and other splendid artifacts, were given to the gods to thank them for blessings received and to ensure good fortune.

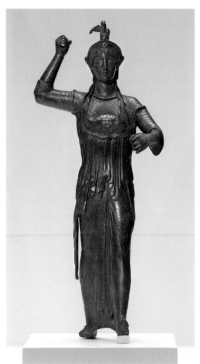

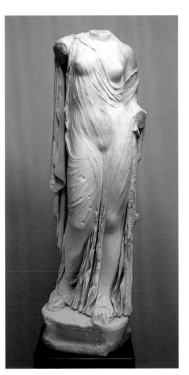

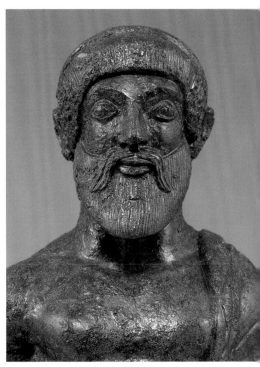

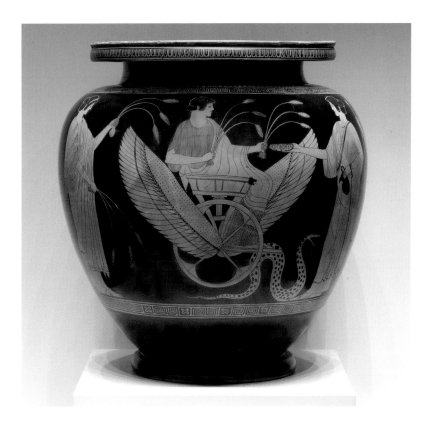

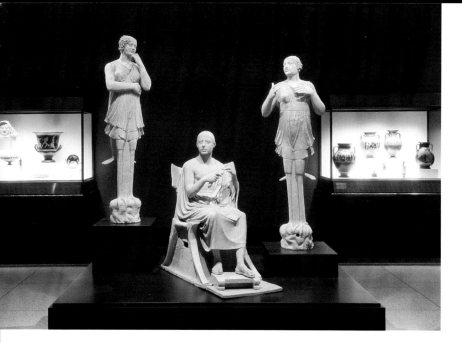

MYTHOLOGICAL HEROES

The Greeks, Etruscans, and Romans considered the heroes of classical mythology to be actual historical figures who lived in earlier times. They embodied positive qualities valued by ancient societies and served as role models for human behavior. Their valiant deeds were widely depicted in ancient art and literature. Mythical heroes usually possess exceptional strength and bravery, specialized knowledge, and other skills that allow them to perform extraordinary feats. Occupying a middle position between the Olympian gods and mortals, most mythical heroes have divine, or at least royal, parents. They frequently suffer from the jealousy or hostility of family members and are forced to overcome dire circumstances. Some heroes perform feats in their homelands. More often they travel to distant realms to combat monstrous beasts and barbarians. Herakles (Etruscan Ercle, Roman Hercules), seen above right fighting the many-headed Hydra, was the most popular hero of antiquity, and many of his deeds are depicted in ancient art. Bellerophon, right, in contrast, is best known for taming the winged horse Pegasos and defeating the monstrous Chimaira. Orpheus, above, was known for his skill as a muscian, rather than for his strength. Still, he defeated the monstrous Sirens (half birds, half women) by singing a more beautiful song.

STORIES OF
THE TROJAN WAR

The epic tale of the war between the Greeks and the Trojans over the abduction of Helen, queen of Sparta, are an artful blend of history and myth. They include gripping scenes of love and hate, war and peace, religion and politics, pride and humiliation. Homer's *Iliad* and *Odyssey* portray the nobility of the ancient Greeks and Trojans and how their sense of honor guided their way of life. These stories were beloved by the Greeks, Etruscans, and Romans, and the power and beauty of the language used to tell them are still appreciated today. The tales inspired such political leaders as Alexander the Great of Macedon, who believed that he descended from Achilles, the greatest of the Greek heroes at Troy. In Rome, the Julio-Claudian emperors traced their lineage back to the Trojan prince Aeneas, who was immortalized in Virgil's epic poem, *The Aeneid*. The colorful Athenian vase (left) depicts the cause of the war: the decision of the Trojan prince Paris to select Aphrodite as the most beautiful goddess in exchange for the hand of Helen, who was already married to the Greek king Menelaos.

PREHISTORIC OBJECTS

The oldest objects in the Museum's collection, made by various cultures in the eastern Mediterranean, date from the Neolithic period to the end of the Bronze Age (ca. 6500–1000 B.C.). Later Greeks, Etruscans, and Romans considered this to be the Age of Heroes. Today we appreciate these objects as works of art, but their makers designed them to serve specific functions, often for religious purposes or as burial gifts. Because prehistoric cultures have left no written history, our knowledge of them depends on the artifacts that survive and the archaeological contexts in which they were found. Many of the Museum's objects do not have a known find spot. Thus scholars have compared them with similar pieces recovered in excavations to understand what they may have meant to the people who created them. The marble harpist, left, was created on one of the islands of the Cyclades in the third millennium B.C. Most such figures have been discovered in tombs.

GRIFFINS

Griffins are fabulous and ferocious hybrid beasts (part lion, part eagle) that symbolize the forces of land and air. In mythology they represented the power of the sun and were sacred to Apollo. They were also associated with Nemesis, the goddess of retribution. The legend of the griffins originated in ancient Near Eastern mythology and art, but it was widely known in Greece. The Greeks (and later the Etruscans and Romans) believed that griffins lived beyond Skythia, the region north and east of the Black Sea, where they guarded a hoard of gold from a neighboring tribe of one-eyed men called the Arimaspeans. Some scholars have argued that griffins, and other ancient monsters, may have been derived from prehistoric animal fossils seen by ancient people. They were depicted in marble, bronze, gemstones, and other media.

VICTORIOUS YOUTH AND ATHLETES

Victorious athletes won honor and fame, not only for themselves, but also for their families and communities. Winners received such prizes as olive wreaths at Olympia, laurel wreaths at Delphi, and special terracotta vessels filled with sacred olive oil at Athens (left). The best-known poets of the day often celebrated victorious athletes in song, and some victors erected commemorative statues of themselves at the sites of the games or in their hometowns. These statues usually depicted the athlete in his moment of glory, crowned (or crowning himself) with a victor's wreath, as in the bronze figure in Gallery 210 (above). Other images of athletes appeared on symposium vessels, mosaics (right), and in other contexts, offering positive models for emulation.

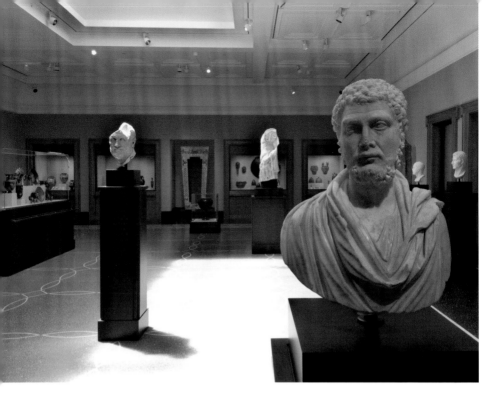

MEN

Men of both high and low social status lived most of their lives in the public arena: they spent much of their time waging war, engaging in politics, and socializing. At home, the man was the head of the household, acting as the sole authority and decision maker. The modern democratic ideal that individuals are born equal was unthinkable in the ancient world. Wealthy men or those who had performed some valuable service might be honored with a publicly displayed portrait statue in either bronze or marble. Further male roles, such as soldiers, philosophers, fishermen, and symposiasts, are depicted in this gallery.

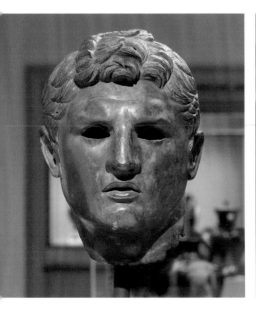

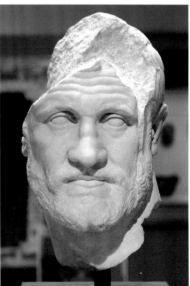

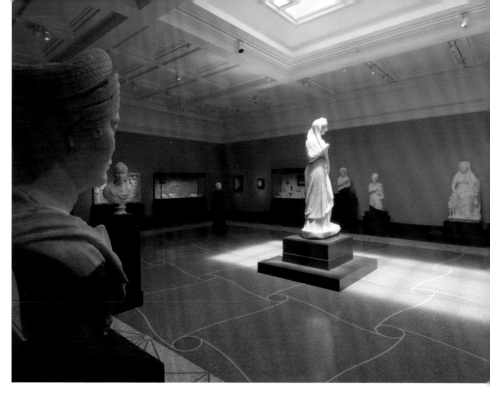

WOMEN AND CHILDREN

Unlike men, most ancient women lived their lives in private. The great Athenian statesman Perikles once said that not to be spoken of at all was best for a woman. Thus there is relatively little ancient literary evidence for women's lives. The visual arts, however, provide a broader picture, especially in the religious sphere, where women served as priestesses and played other important roles in ritual and cult, including burial practices. Copious evidence of toilette articles and jewelry also survives. Images of children often feature their toys, but their lives were quite different from those of their modern counterparts. While upper-class boys were educated in poetry, music, philosophy, and rhetoric, those less well off were generally apprenticed to learn a craft or trade. Upper-class girls were primarily taught domestic skills, such as weaving.

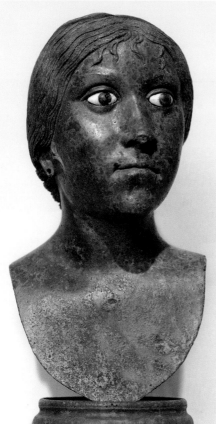

GRAECO-ROMAN EGYPT

Egypt's last independent dynasty of Pharaohs
ended with the ancient Persian occupation in
the late 500s B.C.; in 332 B.C. Alexander the
Great established Greek rule there and founded
the city of Alexandria. After his death in 323 B.C.,
his general Ptolemy established the Ptolemaic
dynasty, which ruled Egypt until 31 B.C. when
Octavian (the later Roman emperor Augustus)
defeated Antony and Cleopatra VII, the last
Ptolemaic ruler, at the Battle of Actium. For
three hundred years under the Ptolemies, Greek
and Egyptian art, religion, and culture mingled.
When the Romans encountered Egypt, a wave
of "Egyptomania" swept the empire, as Roman
forms, such as realistic portraiture, were com-
bined with Egyptian ones, such as mummifica-
tion, to create such unique artifacts as mummy
portraits (right), which are often called Fayum
portraits after the district in Egypt from which
many have been recovered. Today these are
often displayed in isolation as paintings, but,
as seen in the mummy of Herakleides in this
gallery, they were originally part of the linen
wrappings of the deceased.

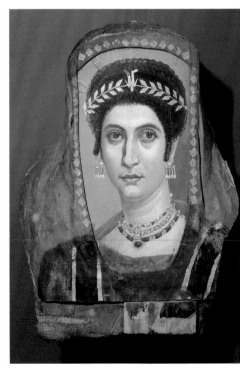

SUGGESTIONS
FOR FURTHER READING

ANCIENT SOURCES

(all available in the Loeb Classical Library series and in other editions)

Pliny the Younger. *Letters.*

Cicero. *Letters* and *Post Reditum in Senatu.*

Statius. *Silvae.*

Martial. *Epigrams.*

MODERN SOURCES

Patrick Bowe. *Gardens of the Roman World.* Los Angeles, 2003.

Maureen Carroll. *Earthly Paradises: Ancient Gardens in History and Archaeology.* Los Angeles, 2003.

Annamaria Ciarallo. *Gardens of Pompeii.* Los Angeles, 2001.

John R. Clarke. *The Houses of Roman Italy, 100 B.C.–A.D. 250: Ritual, Space, and Decoration.* Berkeley, 1991.

Ernesto De Carolis and Giovanni Patricelli. *Vesuvius A.D. 79: The Destruction of Pompeii and Herculaneum.* Los Angeles, 2003.

Joseph Jay Deiss. *Herculaneum: Italy's Buried Treasure.* Revised and updated edition. Los Angeles, 1989.

Joan Didion. "Getty's Little House on the Highway." *Esquire* (March 1977).

David Gebhard. "Getty's Museum. Is it 'disgusting' and 'downright outrageous'?" *ArchitecturePlus* (September/October 1974).

J. Paul Getty. *My Life and Fortunes.* New York, 1963.

J. Paul Getty. *The Joys of Collecting.* New York, 1965.

J. Paul Getty. *As I See It: The Autobiography of J. Paul Getty.* Englewood Cliffs, N.J., 1976. Reprint, Los Angeles, 2003.

The J. Paul Getty Museum. *Handbook of the Collections.* Los Angeles, 2001.

The J. Paul Getty Museum. *Handbook of the Antiquities Collection.* Los Angeles, 2002.

Rick Gore. "The Dead Do Tell Tales at Vesuvius." *National Geographic* 165.5 (May 1984): 557–613.

Wilhelmina F. Jashemski. *The Gardens of Pompeii, Herculaneum and the Villas Destroyed by Vesuvius.* 2 vols. New Rochelle, N.Y., 1979–1993.

Joseph Judge. "A Buried Roman Town Gives up Its Dead." *National Geographic* 162.6 (December 1982): 687–93.

Ethel Le Vane and J. Paul Getty. *Collector's Choice: The Chronicle of an Artistic Odyssey through Europe.* London, 1955.

Carol C. Mattusch. *The Villa dei Papiri at Herculaneum: Life and Afterlife of a Sculpture Collection.* Los Angeles, 2005.

Christopher Charles Parslow. *Rediscovering Antiquity: Karl Weber and the Excavation of Herculaneum, Pompeii, and Stabiae.* Cambridge, 1995.

David Sider. *The Library of the Villa dei Papiri at Herculaneum.* Los Angeles, 2005.

Nigel Spivey and Michael Squire. *Panorama of the Classical World.* London, 2004.

Marion True and Jorge Silvetti. *The Getty Villa.* Los Angeles, 2005.

John Walsh and Deborah Gribbon. *The J. Paul Getty Museum and Its Collections: A Museum for the New Century.* Los Angeles, 1997.

COLORED STONES
IN THE GETTY MUSEUM

Africano (Lucullan).
From Teos, near Smyrna, Turkey.

Amarillo Triana (yellow marble).
From Macael, Almeria, Spain.

Ardesia (slate).
From Chiavari, Genoa, Liguria, Italy.

Bianco chiaro Carrara (white Carrara).
From Ravaccione, near Carrara, Tuscany, Italy.

Cipollino Caristo (Carystian).
From Karystos, Euboia, Greece.

Cipollino di Versilia (Versilia *cipollino*).
From Versilia, near Lucca, Tuscany, Italy.

Fior di pesco (Chalcidian).
From Eretria, Euboia, Greece.

Fior di pesco (peach blossom).
From Stazzema, Lucca, Tuscany, Italy.

Giallo di Siena (yellow Siena).
From Colle di Val d'Elsa, Siena, Tuscany, Italy.

Giallo di Siena Numidia or *giallo antico*
(Numidic yellow).
From Chemtou (ancient Simitthu), Tunisia.

Granito verde della Sedia (green serpentine).
From Wadi Semna (ancient Semna), near the
Red Sea, Egypt.

Grigio Maratona (Marathon gray).
From Marathon, Greece.

Nero del Belgio (Belgian black).
From Mazy, near Namur, Belgium.

Onice ambrato (amber onyx).
From Prilep, near Skopje, Macedonia.

Pavonazzetto antico (Phrygian).
From Afyon, Turkey.

Pentelico (Pentelic striped gray).
From Mount Pentelikon (Latin Mons
Pentelicus), Attica, Greece.

Porfido rosso (dark red porphyry).
From Jebel Dokhan (Latin Mons Porphyrites),
Egypt.

Porfido verde (green porphyry).
From Jebel Dokhan (Latin Mons Porphyrites),
Egypt.

Portasanta antica (Chiote).
From Chios, Greece.

Rosso antico (red).
From Cape Matapan (Latin Taenarum),
Peloponnese, Greece.

Rosso Monte Amiata (Mt. Amiata red).
From Roccalbegna, Grosseto, Tuscany, Italy.

Serpentino (Laconian).
From Sparta, Peloponnese, Greece.

Verde antico (green Thessalian).
From Larissa, Thessaly, Greece.

Verde cipollino (*cipollino* green).
From Cardoso, Lucca, Tuscany, Italy.

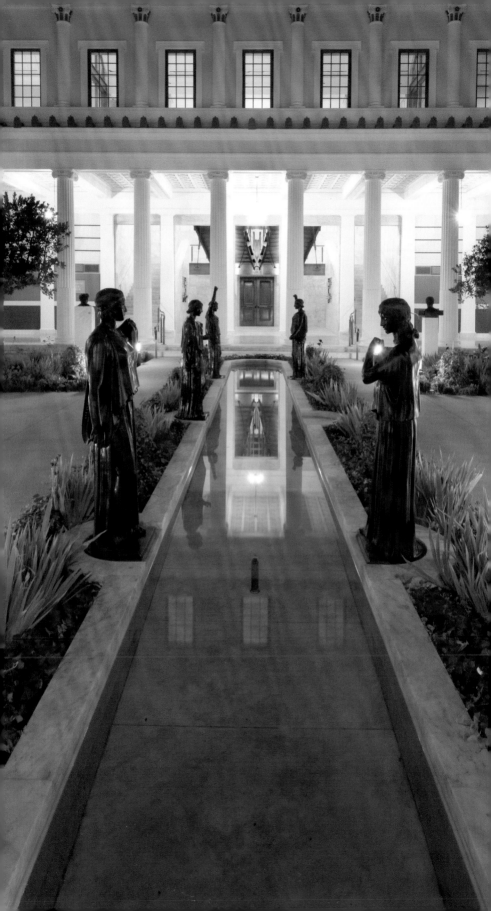

PHOTO CREDITS

B BOTTOM
L LEFT
M MIDDLE
R RIGHT
T TOP

Alinari/Art Resource, NY: p. 44T

Marina Belozerskaya: pp. 32, 52, 53

Martha Breen: p. 44B

e.t. archive, Nicolas Sapieha: p. 47

Clem Fiori: p. 35

Christopher Allen Foster: p. 81

Fotografica Foglia, Naples: pp. 19, 45, 70L, 91, 95BR

David Fuller: p. 30

Stephen Garrett: p. 11B

Eric Geddes, Digital Visualization Group: Floor plans pp. 128–131

Sonia Halliday Photographs: p. 20B

Wilhelmina Jashemski: p. 29

Kavaler/Art Resource, NY: p. 41B

John Kiffe: pp. 18, 23, 28, 31; Los Angeles, Research Library, Getty Research Institute, no. BU1 (10001), pp. 10, 11T, 12, 13T L, 13B, 14R, 15, 27; no. 83-B7535 p. 48T R; no. 84-B21058, pp. 37, 38, 48T L, 62B L; no. 92-B22938, p. 70R; no. 870517. Norman Neuerburg, pp. 42, 43, 58B, 59, 62B R, 68B, 73B, 74B, 76B, 79B, 86, 93B, 94B, 95BL, 96R

J. Paul Getty Museum files: pp. 17, 26T

Daniel Martin: p. 34

O. Louis Mazzatenta, © National Geographic Society: p. 33

The Metropolitan Museum of Art: p. 41T

Morley Construction Company: p. 56

Ellen Rosenbery and Gerard Vuilleumier: pp. 6, 68T, 72, 73T M, 74T, 76T, 79T, 85T, 88, 89, 94T, 95T, 98T, 99, 109B, 110B, 111T R and B, 112M B, 113T, 114B, 115M B, 116B, 117B, 118B, 119B, 120B, 122–25

Jack Ross: p. 39

Richard Ross, © Richard Ross, Principal Photographer of the Getty Villa Project: Front cover, half-title, title page, pp. 8, 25, 26B, 51, 54, 57, 58T, 60T, 62T, 63, 64, 66, 67, 69, 71, 75, 77, 80, 82–83, 85T, 87, 90, 92, 93T, 94T, 96L, 97, 98B, 100–106, 109T, 110T, 112T, 113B, 114T, 115T, 116T, 117T, 118T, 119T, 120T, 121, 132

Scala/Art Resource, NY: pp. 40, 65L

Julius Shulman: p. 80

Sandra Sider: pp. 48B, 49

Jorge Silvetti: pp. 60B, 65R

Soprintendenza archeologica di Roma: p. 16

Marion True: p. 20T

University of Southern California, Specialized Libraries & Archival Collections: pp. 9, 13T R, 14L, 27

Alexander Vertikoff: p. 24

Linda Warren: p. 56, back cover

Bruce White: p. 111T L

Pages 109–120: Object photos

p. 109 Incense burner 87.AC.143.1
p. 110 Bronze Minerva 96.AB.176
p. 111 Venus statue 96.AA.213;
 Bronze Tinia (detail) 55.AB.12;
 Triptolemos vase 89.AE.73
p. 112 Orpheus group 76.AD.11;
 Herakles vase 83.AE.346;
 Bellerophon cup 85.AE.121
p. 113 Judgment of Paris vase 83.AE.10
p. 114 Harpist 85.AA.103
p. 115 Marble 85.AA.106;
 gem 81.AN.76.100;
 bronze 79.AC.140
p. 116 Bronze youth 77.AB.30;
 terracotta oil vase 79.AE.147
p. 117 Boxer mosaic 71.AH.106
p. 118 Bronze head 73.AB.8;
 marble head 91.AA.14
p. 119 Bronze bust 84.AB.59;
 gold wreath 73.AM.30
p. 120 Portrait of Isadora 81.AP.42

Floor 1

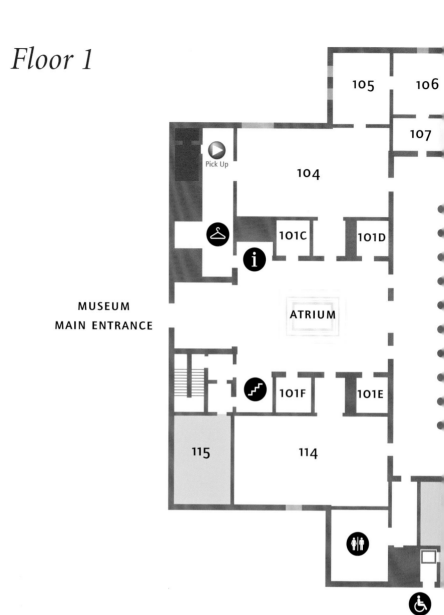

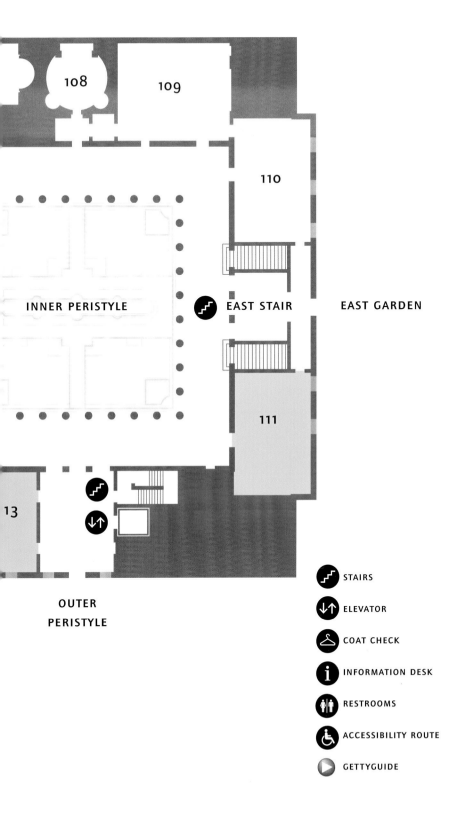

108

109

110

INNER PERISTYLE

EAST STAIR

EAST GARDEN

111

13

OUTER
PERISTYLE

STAIRS

ELEVATOR

COAT CHECK

INFORMATION DESK

RESTROOMS

ACCESSIBILITY ROUTE

GETTYGUIDE

Floor 2

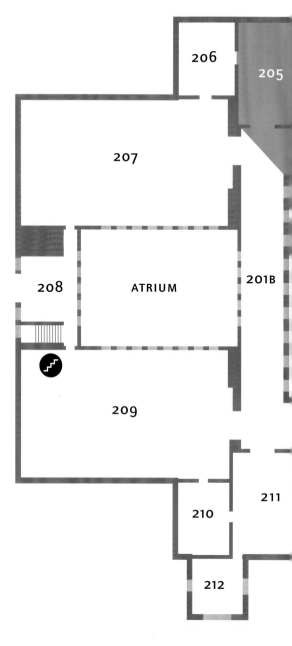

INNER PERISTYLE

EAST STAIR

203

204

201A

202

217

201C

216

213

214

215

STAIRS

ELEVATOR

RESTROOMS

212 Coins, Gems, and Jewelry

213 Griffins

214 Changing Exhibitions

215 Reading Room

216 GettyGuide Room

217 Prehistoric and Bronze Age Arts